CHINESE BRUSH PAINTING
TECHNIQUES

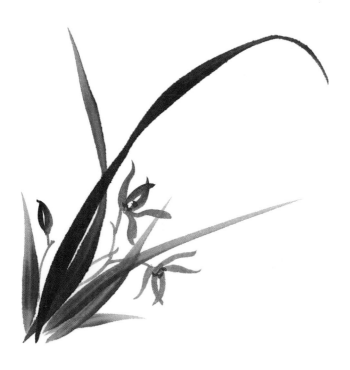

CHINESE BRUSH PAINTING TECHNIQUES

A Beginner's Guide to Painting Birds and Flowers

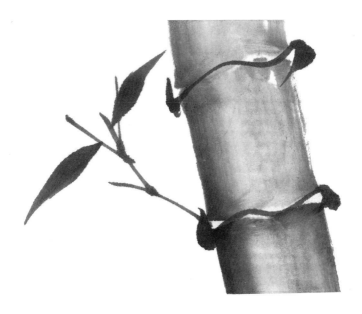

STEPHEN CASSETTARI

ANGUS
& ROBERTSON
PUBLISHERS

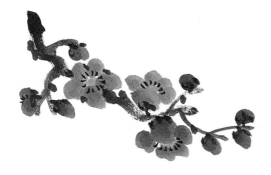

My most grateful thanks are given to Mrs Kate Campbell, Principal of the Mosman Evening College, for the help of her staff and the use of her equipment.

ANGUS & ROBERTSON PUBLISHERS

Unit 4, Eden Park, 31 Waterloo Road,
North Ryde, NSW, Australia 2113, and
16 Golden Square, London W1R 4BN,
United Kingdom

First published in Australia
by Angus & Robertson Publishers in 1987
First published in the United Kingdom
by Angus & Robertson (UK) in 1987
Reprinted in 1988

Copyright © Stephen Cassettari 1987
(Year of the Rabbit)

National Library of Australia
Cataloguing-in-publication data

Cassettari, Stephen.
 Chinese brush painting techniques.
 ISBN 0 207 15538 0.

 1. Ink painting, Chinese—Technique. I. Title.
751.42'51

Typeset in 11/12 Baskerville by Midland Typesetters
Printed in Singapore

CONTENTS

INTRODUCTION

In traditional Chinese painting, the same materials, principles and techniques are used as in Chinese calligraphy. Both arts evolved gradually, over many centuries, and have been called "the twin sisters of the brush".

The beginnings of Chinese art can be traced back to about 1766 BC, when pictorial characters or ideograms clearly representing an object (such as a person, a boat or a fish) were carved in thick, even lines into bone or stone. On the one hand, these ideograms developed into writing or calligraphy, gradually becoming more stylised. On the other hand, they developed into pictures, which in time became less abstract and more impressionistic in style.

The oldest surviving silk paintings date from the 3rd century BC. (Artists probably painted on silk and lacquer as early as the 12th century BC, but no examples have survived.) These ancient fragments show a similar technique to the early ideograms, but the regular outline is painted in black ink and filled in with a colour wash.

The invention of paper in China about 105 AD brought about a revolution in style. Painting with a soft brush on paper, a much more absorbent medium than silk, gave artists a freedom previously unknown. It allowed them to develop a truly personal, spontaneous style — a vibrant, changing brush stroke that bears the artist's individual stamp (as individual as handwriting). This is when calligraphy really began to develop as an art form, with different styles emerging, and it is this style of brush painting that is explored in this book.

The subjects of early paintings were animals, religious and historical figures, and court scenes. Landscapes appeared in paintings as a background to human figures in the 4th century AD, but it was in the 7th century that landscape painting emerged as a separate genre, reaching its peak during the Sung Dynasty (960–1279 AD).

Landscapes were painted mainly in black and tones of black washes, but some artists also used soft colour washes.

During the Ming Dynasty (1368–1644 AD), some painters began to concentrate on and to develop more intimate views of nature — for example, one branch (in flower or with a bird sitting on it) rather than a forest of trees, or a single rock beside a stem of bamboo rather than a whole mountain landscape. This trend has continued to this day. While other subjects such as landscapes, figures and religious scenes are still painted, the more simplified subjects are the most often seen and appreciated, expressing, as they do, the very essence of this art form, with its minimal use of colours, its spontaneous, seemingly effortless brushwork and its use of space.

To appreciate Chinese painting, the viewer needs to have some concept of Yin and Yang, the two complementary forces or principles that are to be found in all the aspects and phenomena of life. This concept is the inspiration for both the subject matter and the style of Chinese painting.

What the artist aims to do is to hold (and so to reveal to the viewer) the essence of a moment in nature — the quiet motion of a bird on a branch or flower, young bamboo growing in the spring sunlight, the gentle pausing of a butterfly on a flower. Painting is "silent poetry". In this tradition, the blank spaces — the space between petals, for example, or the distance between two birds — are vital to the composition, counterbalancing the weight of the brush strokes. It is as if the white spaces are being carved out with each brush stroke. The final form should seem to lift clear of the page, giving the impression that the bird could turn its head and sing, or the bamboo might start to quiver in the wind.

The qualities that the artist is striving for were formulated by the painter Hsieh Ho in the 5th century AD and are known as the Six Principles. These principles are elaborated after the section on materials, and students will find it helpful to return to them often.

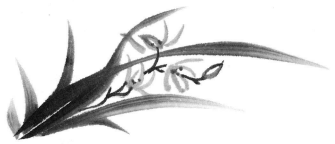

In the Chinese tradition, it is not only acceptable to learn through copying, but an inspired copy or interpretation of another painting can be a work of art in its own right. This is how the essence (or spirit) of painting is transmitted from one generation to another. But it is always essential to study the subject from nature, as this is the endless source of inspiration, Books, calendars and cards are good sources of ideas and reference.

Reading about the history of Chinese art will help to deepen your appreciation of Chinese painting, and this, in turn, will help you to refine your own skills.

This book is designed to be worked through step by step. Don't pass over any of the exercises, even if a subject does not appeal to you. Each builds on the skills developed in earlier exercises and introduces something new. Later you can repeat the subjects you like best to develop your technique. Remember, when the work becomes the most difficult, that's when you are learning the most.

A book is no substitute for a teacher, who can guide your hand and with whom you can discuss your progress, but it is better than no teacher and it can be a great help during your practice sessions. Keep in mind that two to three hours' practice is usually long enough, but even half an hour is worthwhile.

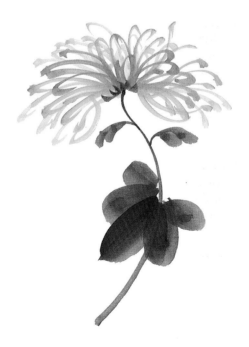

THE FOUR TREASURES

The basic equipment used in traditional Chinese painting is handmade from natural materials. It is precious both for the work that has gone into making it and because it is the means by which artists execute their craft.

1 BRUSH

The brush is usually made from animal hair set into a hollow bamboo handle. The better-quality brushes have some sort of binding, or sometimes a piece of copper, where the handle joins the hair, to hold both together and prevent the bamboo from splitting. A piece of tape can be applied for the same purpose. There is usually a loop on the end of the handle so that the brush can be hung up to dry.

When you are starting off, you need just two brushes. A soft, white-haired brush made of goat's hair, of about the size shown, is a good brush to begin with, as it is easy to use, pliable and holds a lot of water. This type of brush is particularly suited to painting flower petals. You will also need a firmer, red-haired brush made of deer, squirrel or other animal hair, about the same size as the other, for painting leaves and for sharp line work. Later you may like to add a smaller vein brush made of similar hair for outline and fine detail work. Brushes are not numbered by size as other painting brushes are, but a wide variety of brushes designed for different uses is available.

Handle about
16 cm long

Vein brush
(actual size)

CARE OF BRUSHES

After buying your brushes, discard the bamboo covers and soften the hairs in cold water. Always wash brushes in cold water and occasionally soap, never in hot water, and shape the brush tip to a point to dry. Carry your brushes in a rolled mat to protect the hairs.

2 INK-STICK

To begin with, a tube of black watercolour of student quality is good enough. It is better not to use acrylic or poster paint, and Indian or similar ink should definitely not be used, as these can destroy the hairs of the brush. Later you will need an ink-stick, which is made of solidified soot (usually pine) and fish glue. Don't buy the similar ink that is available in bottles, as this is designed for calligraphy and does not dilute well to produce the varying tones.

3 INK-STONE

You will also need an ink-stone to grind the ink. A simple ink-stone, either round with a lid or oblong with a shallow end, is best. The heavier, more expensive ones are made of natural stone.

To grind the ink, first place a cloth underneath the stone to prevent it from sliding. Wet the surface with just a couple of drops of water, hold the ink-stick upright (as you would a brush) and grind it gently on the stone in a continuous motion, either up and down or round and round, as shown below, until the ink is very dark (at least 5 to 10 minutes), adding more water as needed. The ink can be picked up with a brush directly from the stone or placed on a palette and mixed with water to achieve various tones of grey. Ink can be left for an hour or so if it is covered.

Don't leave the ink-stick standing on the stone, and don't hold the stick too tightly, as this could break the stick. Wash the ink-stone clean after each use.

4 PAPER

Newsprint, the paper newspapers are printed on, is the best paper to begin with. It can be bought in the form of scrapbooks, or ends of rolls or blocks can be bought direct from a printer. Cartridge paper and most art papers are not suitable, as they are not absorbent enough.

After a little practice, it is advisable to begin using rice paper. This comes in rolls and sheets and is made from a variety of natural materials such as cotton, rice plant and mulberry. A very white paper made from cotton fibres is best for all-purpose work. Use the smooth side for most subjects — flowers, birds, people and so on — and the rough side for landscapes. Most rice paper is highly absorbent. Experiment with different types to discover which you like best for various effects. The finer the paper, the more control you have over the line; for example, a very fine, white paper is best for rendering the sharp strokes of bamboo, and a very absorbent paper is best for soft flower petals.

Always carry rice paper rolled or flat in sheets. Never fold or crinkle it, as this makes the surface difficult to paint on. A cardboard tube is useful for carrying paper.

To tear rice paper, simply run a wet brush across the surface, making an even, thin line of water, and pull the paper apart slowly.

Once you have gained some practice on newsprint, the sooner you start using rice paper the better. You will get better results, and you will also learn the importance of working quickly. When using rice paper, first place a piece of newsprint or felt underneath to absorb any excess water that soaks through the paper.

OTHER EQUIPMENT

- Two small containers, one for washing the brush and one to hold clean water (which is essential when you are trying to achieve pure colours for flowers).
- A palette, or several small white saucers, or a white tray, for mixing colours and tones of black. (White is best, as it shows up the true colours.)
- An absorbent cotton cloth for soaking up excess water from the brush.
- A set of Chinese colours in tubes. Tubes are the most convenient form of colours. Originally the colours were also made in stick form, like the black ink-stick, from various mineral and vegetable dyes. These can still be obtained; being softer than the black, they can

be mixed on a small white saucer and do not require an ink-stone. They produce a paler colour, more suitable for washes, especially in landscape painting.

The colours can also be bought in pans. This form is best for painting flowers, because the consistency is thicker. Colour flakes are also available, but these are not as convenient and are not recommended.

All this equipment is obtainable from most well-stocked art suppliers. Most of it can be found in some Chinese or Japanese bookshops or even in oriental grocery shops, as this is the standard equipment used by children learning calligraphy.

The range of Chinese watercolours is different from that in a set of Western watercolours. The latter can be used, but you will need to mix them to obtain colours similar to the Chinese colours.

If you wish to use ordinary watercolours, you can buy them in individual tubes, for example from Winsor and Newton's Cotman range. The colours closest to the Chinese colours are listed here (and will need to be mixed as explained in the instructions for individual paintings):

Red — Alizarin crimson
Blue — Indigo (for deep blue)
 — Cobalt (for light blue)
Brown — Burnt sienna
Yellow — Gamboge
Green — Traditionally mixed with gamboge and indigo, but sap green can also be used.
White — Use only for flowers and birds painted on coloured paper. *Only water (not white) is used to lighten tones.*

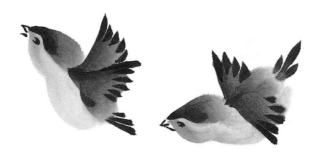

THE SIX PRINCIPLES 六法

The qualities the artist is striving for were formulated by the painter Hsieh Ho in the 5th century AD. They are known as the Six Principles.

1.氣韻生動 "Breath — resonance — life — motion" (Lifelike spirit) A spiritual flower growing on the tree of craftsmanship, this quality cannot be taught like the following five principles. It is like blossoms on strong shoots, flowing from within — it is the energy of heaven in harmony with the world, a perceiving and re-creating of the inherent spirit of the subject.

> The wind rises from the green forest, and the foaming water rushes in the stream. Alas! such painting can not be achieved by physical movements of the brush but only by the Spirit entering it. This is the nature of Painting. Wang Wei (8th century AD)

2.骨法用筆 "Structure — method — use — brush" (Deft brushwork) Line, rather than the light and shade of Western art, is the basic structural element of traditional Chinese painting. The brush becomes an extension of the arm, the body, the mind — it is the artist's heart-print.

Through practice, you will develop the muscular control that will give your brush strokes an imprint as personal as handwriting (calligraphy), resembling a dance of energy, movement and life. There is a saying that the artist's brush strokes should be:

> Like a flock of birds darting out of the forest, like a frightened snake disappearing in the grass, like cracks in a shattered wall.

3.應物象形 "Fidelity — type — depict — form" (Accurate likeness) Aim to portray the spirit through the form. Which is more important, exact representation or free expression? A painting should have

recognisable form, but the spirit of the subject is more important. It is sometimes said:

> An artist who can capture life has to be adept at representation, but a good representationalist cannot always capture life.

4. 經營位置 "Division — planning — placing — arranging"
(Well-planned space)

Composition comes about through a proper balance of elements — large, medium and small. In Chinese, this relationship is referred to as the host, guest and servant. The subject is balanced by the empty space in the painting.

Three-dimensional effects can be achieved by overlapping dark with light, by placing together large and small.

There is a different perspective in a Chinese scroll, which is designed to be held in the hands and viewed from right to left, from that in a Western-style framed picture, which is seen as through a window. A scroll is unrolled and viewed in sections, and so it is not confined to one fixed viewpoint but is subject to a constantly shifting perspective. It is not meant to be understood just by viewing it with the physical eye. The 'inner eye' must combine the various perspectives that unfold as the viewer looks *into* as well as along the picture. This adds to space the dimension of time.

5. 傳移摸寫 "Transmitting the past" (Venerated traditions)

By copying established forms, one becomes free to concentrate on giving life to that form. Showing reverence for the past, one builds upon it like a mighty city reaching to heaven. An exact duplication lacks the essential ingredient of spontaneity. Attempt free variations on traditional themes.

6. 隨類賦彩 "According — object — apply — colour"
(Versatile colours)

The colours of a painting should match the hues of nature. In oriental painting, colours represent both the seasons and the elements, and the artist's materials also represent the elements:

green	spring	wood	brush
red	summer	fire	inspiration
yellow	centre (late summer)	earth	pigments
white	autumn	metal	ink-stone
blue/black	winter	water	water (the medium of watercolours)

By varying tones, the artist can capture the texture of the subject: thus fragile petals are best painted in a light tone; flexible leaves in a wet, dark tone; strong, rigid branches in a dry ink.

Paint with joy, with the sheer pleasure of singing life's song.
Paint with love and kindness for the materials and the subject portrayed, becoming one with both.
Paint with compassion, sensitive to the need of the paint to sing its song, of the brush to follow its way, and of the paper to receive the subject mirrored through your eyes.
Paint with the patience of water washing away a mountain.

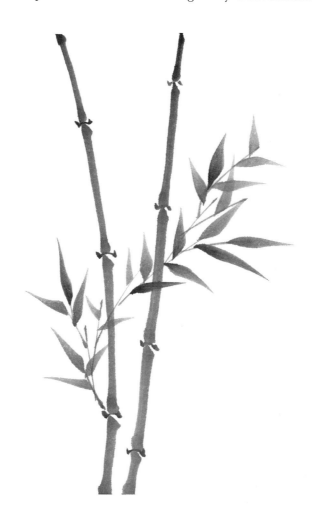

BASIC BRUSH STROKES AND TECHNIQUES

There are two main differences between traditional Chinese painting and other forms of painting.

- Each stroke must be completed in a single movement. The artist aims to give an impression of the subject as if seen in the blink of an eye. Allowing each stroke to remain as it is first placed on the paper expresses the very heart-print of the artist, like a musical note or a spoken word.
- The brush is loaded with at least two and up to four tones or colours. (This includes water, which is considered to be a separate tone.) This variation in tone gives the painting a spontaneous quality, a life of its own. The artist's creation can never be a real flower or bird, of course—it can never grow or fly—but it can have its own reality and beauty and be appreciated for this as well as as a representation of the subject.

In Chinese painting, opposites complement each other—they don't oppose. Some of the opposites used are: light/dark, space/fullness, thick/thin, large/small, old/young, dry/wet, hard/soft, long/short. Some of these techniques are shown on the following pages.

Try all exercises both much larger and smaller than the examples shown. Paint the long lines as long as the paper you are working on and as thick as the width of the brush will allow. Then do them as finely as you can.

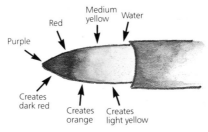

THICK/THIN

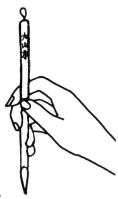

FIG. 1 Load a brush fully with dark ink, and hold it vertically to the paper (which is flat on the table). Holding the brush just below the middle of the handle, place your first two fingers in front and the two smaller fingers behind, with your thumb in the middle of the brush, level with your index finger. Place the brush on the paper and move it along to make a line of even thickness, keeping your wrist and fingers still and your elbow suspended above the table — move from the shoulder when drawing vertical lines and from the elbow when drawing horizontal lines. Once you get used to holding the brush in this way, you will find that it gives you great control. The number of brush hairs that are in contact with the paper will determine how thick the line is. The aim is to maintain an even thickness of line throughout each stroke.

Try painting in all eight directions, and try both brushes, to become aware of the different effects. After practising lines, try some circles and spirals.

Note that you should always hold the brush in this way, regardless of the angle at which you are holding the brush.

FIG. 2 Press the brush down fully (to the base) and pull it along.

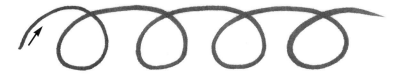

FIG. 3 To draw a thinner line, use just the tip of the brush.

FIG. 4 Move your arm from the shoulder to draw smooth, round lines.

HARD/SOFT

To draw a **hard** line, of the sort used for branches, rocks and bamboo stems, for example, vary the line by stopping and then restarting it without lifting the brush off the paper. For this sort of line, a white goat's hair brush is best.

FIG. 5 Place the tip of the brush on the paper first, then lay the rest of the hairs down, pull the brush along, stop, and increase the pressure slightly to create a nodule. Lift the brush (but not off the paper) and pull it along again. At the end, stop and pull the brush back slightly to form a firm, round end.

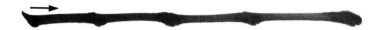

To draw a **soft** line, of the sort used for an orchid leaf, for example, gradually lift the brush as you move it across the paper, and when only the tip is touching the page, gradually apply more pressure to thicken the line again. The brush moves continuously in this stroke. For these soft lines, the stiffer deer hair brush holds a better point.

FIG. 6 Start with the brush slightly above the paper. Move it along and down, touching down the tip first and then gradually increasing the pressure to make the line thicker, then lifting the brush on its tip again, then applying more pressure, and so on. At the end, lift the brush gradually off the paper to finish at a point. Keep the brush moving throughout the stroke. The movement is like an aeroplane touching down and then gently taking off again several times.

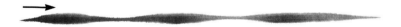

These two lines make use of all the opposites and are the most important strokes to master. Together, they contain all the techniques you will need. You should practise them often, trying both lines and circles in various directions and thicknesses.

LIGHT/DARK

FIG. 7 This stroke is used for bamboo stems. Begin by loading a white-haired brush with clean water, wiping off any excess on the side of the container. Then, on no more than the top third of the brush,

add medium-thick green, and finally tip the brush in thick black ink. (You will learn to judge the quality of colours with experience.)

Holding the brush at a low angle, paint a single, hard stroke. The tip of the brush forms the outside edge. To do this stroke, press the brush down, then lift it (but not off the paper), and move it along. At the finish, press down again and pull back a little over the stroke before lifting the brush up, to create a round end.

The lower the angle of the brush, the thicker the stroke. You will need to adjust the amount of paint accordingly, so that all three colours appear. (Again, this comes with experience.)

LONG/SHORT

Now that you have practised some long strokes, here are some small strokes, which are ideal for flower petals and small leaves.

FIG. 8 Load a white-haired brush with clean water; then load the top half in a light red and the tip in black. Holding the hairs of the brush at an angle of 45°, place the tip down first, then sit the brush on its heel to create a round end. (This is like doing the beginning of the hard stroke, but instead of pulling the brush along, you simply lift it up again.) Always place the tip of the brush where the darkest part is needed.

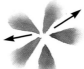

Now practice the following strokes to develop ease and spontaneity. In the following diagrams, the number indicates the beginning of each stroke, and the arrow shows the direction of the movement.

FIG. 9 This is called the bone stroke. It is also the Chinese character for *one*. Press down, lift up, pull along, press down, and pull back over the stroke to make a round end.

FIG. 10 Here, three bone strokes are combined to make a stem of bamboo. Paint the first stroke downwards and the other two upwards.

FIG. 11 This sharp stroke is used for bamboo leaves. For this stroke, the brush has to be very upright, with the hairs pointed, and your elbow should be out from your body. A red-haired brush is best for obtaining a needle-point. Press down firmly at the start, as with the hard stroke, then lift slightly and pull the brush slowly towards you, lifting gradually and finishing in a point, as with the soft stroke.

FIG. 12 Paint these two series of strokes in one movement of the arm, the gap between each stroke being where the brush has left the paper.

FIG. 13 For this teardrop, pull the tip of the brush across the paper, slowly increasing the pressure (as in the orchid leaf stroke) before sitting the rest of the hairs down, and finish by pulling the brush back over itself as in the hard stroke. (When you lift the brush up, sometimes a water mark is left on less absorbent paper. This is quite acceptable.)

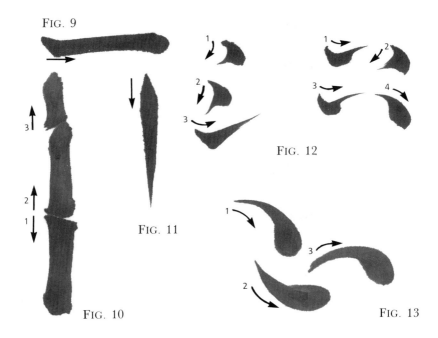

FIG. 9

FIG. 12

FIG. 11

FIG. 10

FIG. 13

THE FOUR SEASONS 四君子

Painting the following subjects, which symbolise the four seasons, is a traditional way of learning the techniques and principles of composition inherent in all Chinese painting, subjects and styles. These subjects require you to use all the basic brush strokes explained in the previous pages. (The Four Seasons are also known as the Four Gentlemen, as each subject represents the quality of character that, ideally, a gentleman should cultivate during that season.) For all these subjects, use the smooth side of the rice paper (the inside of the roll).

Paint the seasons in the order given, as the techniques build on those in each preceding exercise.

ORCHID—*Spring (Modesty)*

This subject teaches you the technique of painting leaves, emphasising curved lines. The orchid is a symbol of both joy and modesty, with its small flowers of bright colours and exquisite perfume almost hidden among common, grass-like leaves.

Let the leaves and the flower petals dance freely in the fresh wind, to emphasise the vitality of the season.

LEAVES

Begin with the leaves. The first leaf is called the host leaf, because it is there to greet the guest on arrival (the second leaf). The third leaf is called the servant, arriving last to assist the other two. The more resilient deer hair brush is best for this—it will help your strokes to express the vitality of spring.

Always turn the leaf when the brush is on its tip, *not* on a thick section.

FIG. 1 The host leaf. Load the brush with light grey ink (black mixed with water), then tip with thick black. Starting at the base of the leaf, paint the leaf as explained for the soft stroke (p. 10). All the leaves should be painted without reloading the brush for the sake of continuity, but after several strokes the brush may need to be repointed and perhaps retipped in black.

FIG. 2 The guest appears after the host and helps to balance the composition, being smaller and moving in a different direction.

FIG. 3 The servant's function is to support the host. He is similar in attitude and direction but smaller.

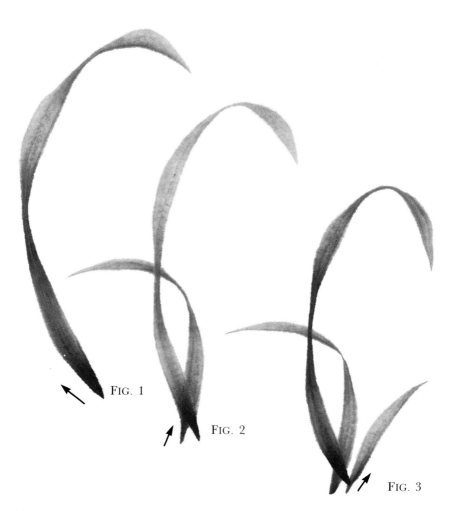

FIG. 1

FIG. 2

FIG. 3

FIG. 4 Add the small leaves (like little children) to give weight to the bottom of the picture. Place these leaves on different levels to create a feeling of depth.

FIG. 5 The finished composition — add the flowers and buds, then the stems, and finally the centre (face) of the flowers, as explained on the next page.

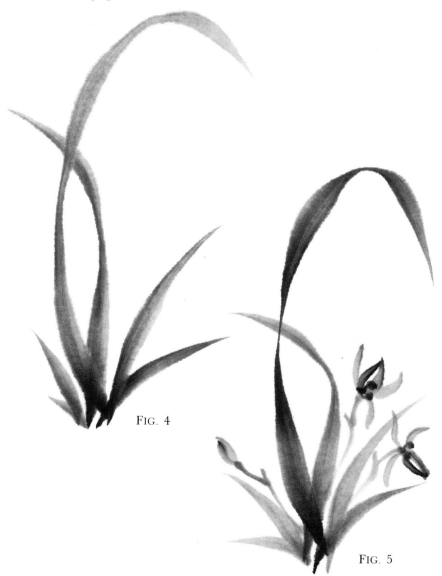

FIG. 4

FIG. 5

15

FLOWERS

Each flower has five petals at most. The spirit of the orchid is joy — make each flower dance with happiness.

FIG. 1 Load the brush with water, then with light grey, and tip with a little black. Begin with one of the two centre strokes.

FIG. 2 The same two strokes, but tighter, form the buds, which can be slightly darker than the older flowers.

FIG. 3 Paint each petal towards the centre of the flower.

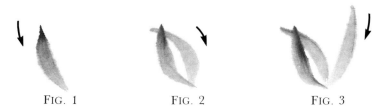

FIG. 1 FIG. 2 FIG. 3

FIG. 4 All the petals should be painted without reloading the brush, and the petals should gradually become lighter.

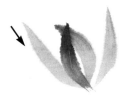

FIG. 5 Add the stem with a couple of fine lines, thicker at the base of the flower and disappearing among the leaves.

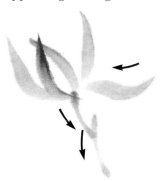

FIG. 6 This is the Chinese character for *heart* (the centre of joy) and some abstractions of the character. Any of these, painted in dark black, can be used for the centre of the orchid. (Don't add centres to buds.)

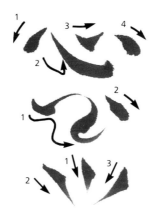

FIG. 7 You can also paint an orchid with all the flowers on one stem. Try to do all five flowers without reloading the brush—just add a touch of black at the tip when starting each new flower. This will give the appearance of young, bright buds and an older, faded flower further down the stem.

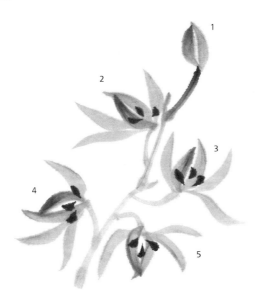

Now try these compositions.

Leaves: Load the brush with water, then with medium green mixed with indigo, and tip with dark black.

Flowers: Load the brush with water, wipe off the excess, and add purple to the tip. Paint all the flowers without reloading the brush, starting with the buds and then doing the older, faded flowers.

Stem: Use the same green as for the leaves, but without the black.

Centre: Black.

It does not matter if you don't achieve exactly the colours shown here, as each palette of colours will be different. But be conscious of the tonal values you are using.

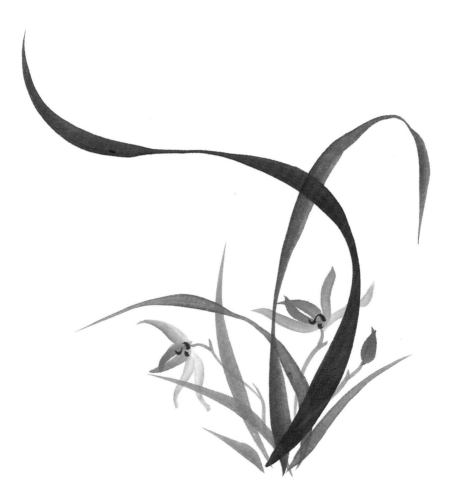

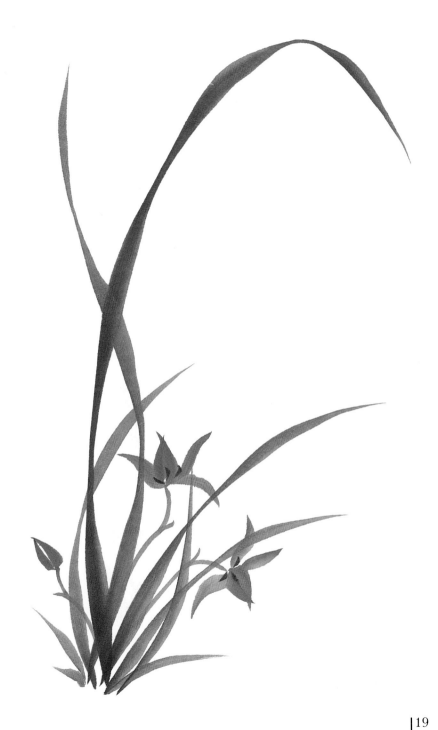

19

Two subjects together must "talk" to each other, one active (yang) and one passive (yin).

Paint the leaves of both plants first, and then add the flowers and stems.

Study the patterns of white spaces formed by the black lines of the leaves.

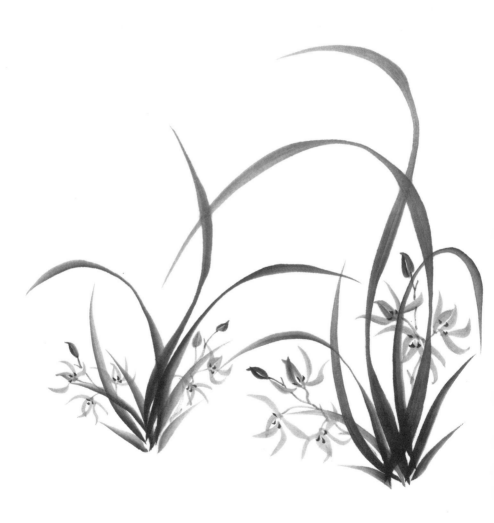

Because they exemplify the characteristics of yin-yang, the orchid (curved, soft) and bamboo (straight, firm) have often been painted together to form a classical composition.

Paint the orchid first, and then the young bamboo (as shown on p. 36).

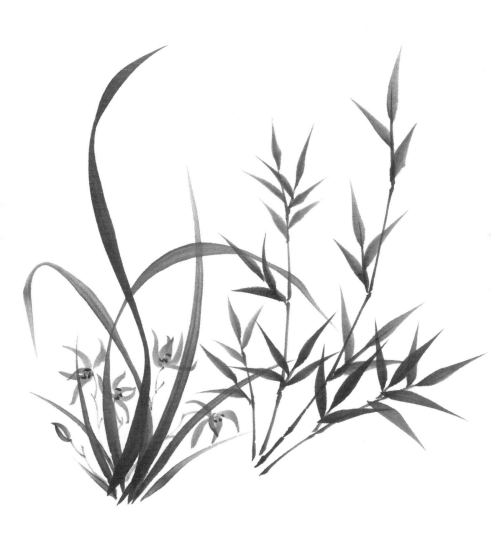

In these paintings, an old, eccentrically shaped rock balances and contrasts with a soft, young orchid.

- Paint the rock first, then the orchid.
- For the rock, load a white-haired brush with water, then with yellow ochre mixed with burnt sienna, and tip with black ink. Lay the brush fully on its side to paint the top; then paint the side edge in a hard, jagged motion; then do another stroke beside it to thicken the rock.

 For the rock below, finish with a base stroke, as shown in the diagram.

 For the rock shown opposite, leave out the base stroke, to create the impression of greater height.
- Paint the moss while the rock is still slightly wet, using a brush loaded with water, then with medium green, and tipped with black.
- After painting the orchid leaves, paint the flowers, using a brush loaded with water, then with yellow, and tipped with red. Use black or a deep purple/red for the centre of the flowers.

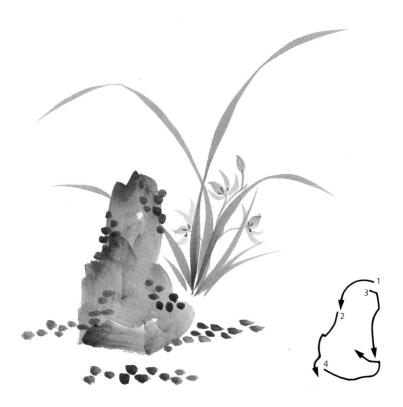

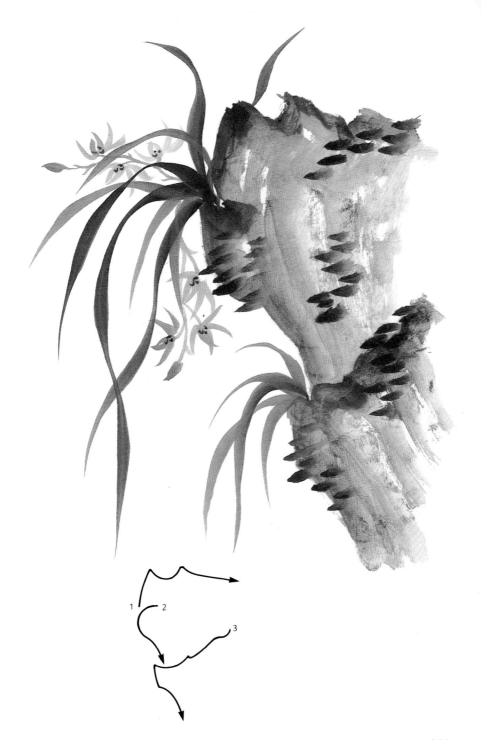

PLUM BLOSSOM—*Winter (Hope)*

This subject teaches the technique of painting the hardness of branches, trees and rocks, which is used in many different flower compositions. In Chinese flower painting, each part is given equal emphasis, so the branches and leaves are painted with as much care as the flowers.

The plum blossom is a contrast of a very old, rugged tree with young, soft blossoms. The blossoms sometimes appear when snow is still on the ground, thus signifying hope and faith in the return of spring.

BRANCHES

Paint the branches first. The form of the composition is established in the very first stroke (as with the host leaf of the orchid and the stem of the bamboo). A white-haired brush is used for dry strokes, as this technique would damage the point on a deer hair brush. To achieve dry ink, wet the brush, wipe most of the water off on an absorbent cloth, and then dip the brush in thick black ink. Dry effects are best achieved by painting quickly and with not as much pressure.

FIG. 1 Holding the brush at an angle of about 45°, drag it across the paper in a jerking motion, pressing hard at each elbow of the tree (a variation of the hard line described on p. 10).

Establish the main branch first, and you will find that, instead of being a difficult task, the composition will grow naturally from the tree.

Notice how, by increasing the angle of the brush, you can make the branch taper off gradually.

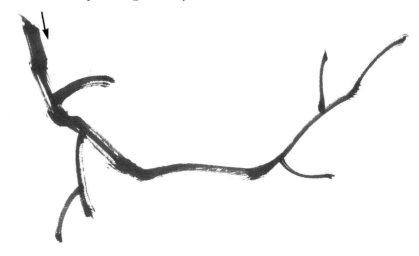

Add small side branches from the main trunk, making sure that they are firmly attached and finishing in a knob, ready for next year's growth.

FLOWERS

Use a white-haired brush to paint the flowers, first loaded with light grey and then tipped ever so slightly in black ink.

FIG. 2 Placing the brush at an angle of about 25°, move it in a tight circle, with the tip remaining at the base of the petal.

FIG. 3 Add a second petal beside the first. Again, the tip of the brush should point towards the centre of the flower.

FIG. 4 This is the easiest way of achieving a symmetrical, five-petalled flower.

FIG. 5 Make sure a space is left to form the face.

FIG. 6 Draw a circle in dark black in the centre of the flower. Then add fine needle strokes, using small, sharp bamboo leaf strokes, and small pollen dots, all in very dark ink, to suggest the vibrant new life contained in the seeds.

Or you can do a simpler version, without the pollen dots, as shown.

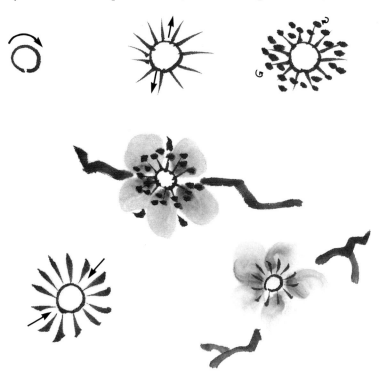

FIG. 7 The bud is painted in the same way as a single petal but can be darker. Add the calyx in dark, sharp strokes, making sure they are attached firmly to the branch. Use the red-haired brush for the calyx and flower centres, as this permits a finer line.

FIG. 8 Side view of a flower.

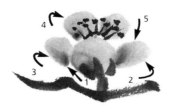

FIG. 9 A finished composition. Note the following points:
- When painting the branch, remember to leave a gap for the flower.
- Place buds towards the ends of the branches.
- Give each flower its own character by giving it a different direction from the others.
- Add a calyx and centre to each flower.
- Add moss dots, using dark, wet ink. Moss dots indicate a tree of great age, like a beard on an old man.

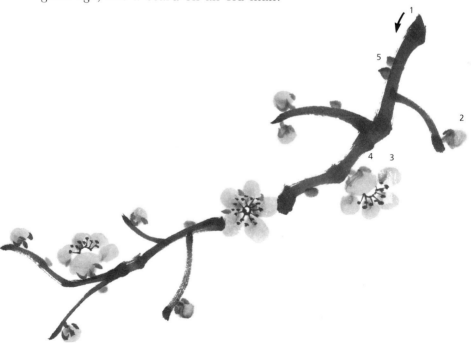

Here are two compositions for you to try. Having mastered these, you can then experiment with your own compositions.

- For the branch, load the brush first with water, then with brown, and tip with black.
- Paint the flowers with a very wet brush loaded with medium red and tipped with darker red. If the flowers run, use less water and work quickly.
- Use dark green for the sepals, yellow for the flower centres, purple for the stamens and blue/black for the moss.

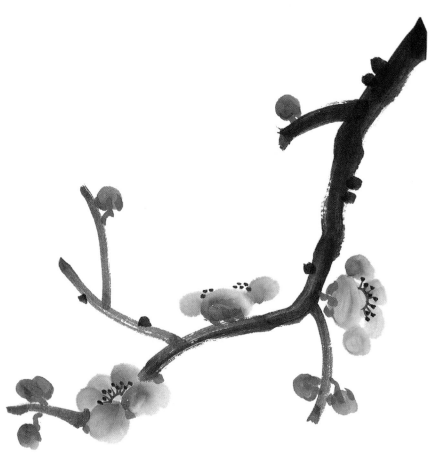

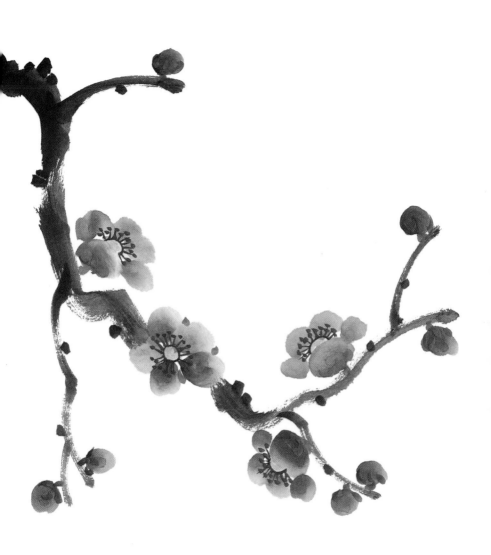

The "contour" style shown on these pages is not only an effective method of painting a white flower but will also help you to better understand the line of each petal.

- To paint the composition shown below, use the same strokes in the same order as you did for the previous plum blossom examples. However, to paint the flowers, construct each petal with two medium-tone strokes similar to the bone stroke (see p. 12), only finer and curved.
- For the stamens, use a short, dark bamboo leaf stroke.

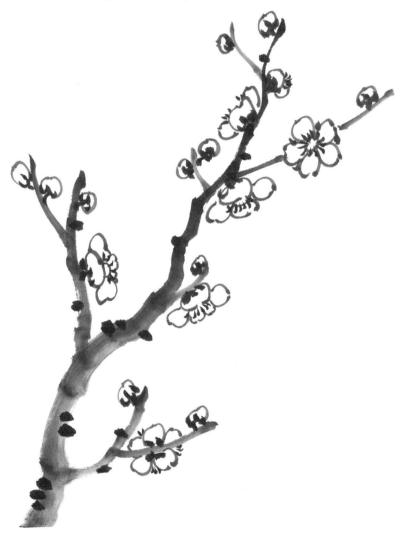

For this composition, paint the plum blossom first. Add the young bamboo stems, and then the leaves in a medium tone.

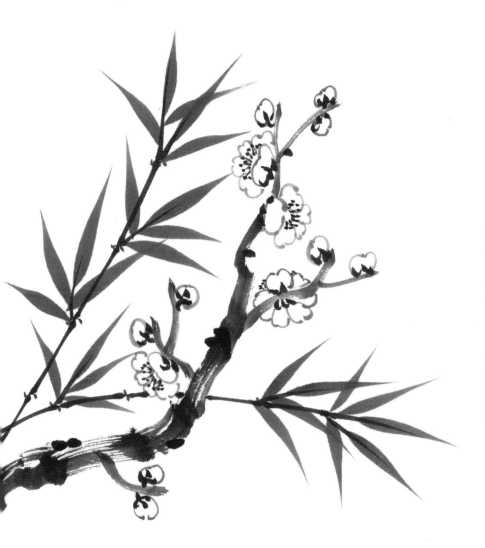

For this composition, you will need to look ahead to the section on painting birds (pp. 61–3).

- Paint the bird first, using burnt sienna tipped with black for the top of the head and the wings, yellow ochre for the underbody and black for the details.
- Add the branch and flowers.
- To make a balanced composition, place the bird across the branch, as in Fig. 1 — **not** as in Fig. 2, where all the lines are moving in the same direction.

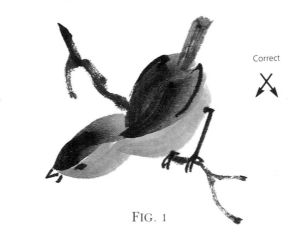

Correct

FIG. 1

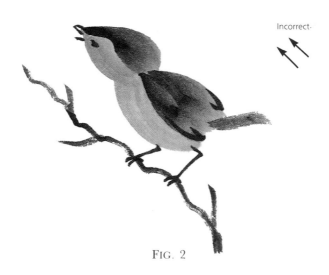

Incorrect·

FIG. 2

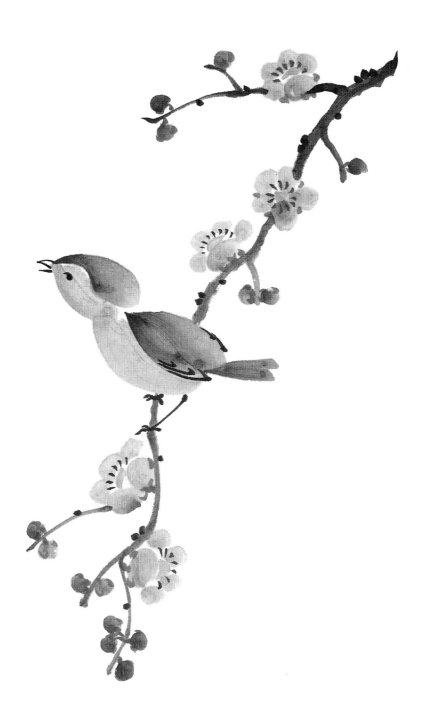

BAMBOO—*Summer (Gentle Strength)*

Painting bamboo exemplifies all the Chinese principles of composition in the clearest, simplest form. It can be one of the most difficult subjects to paint but also one of the most rewarding. Many Chinese artists will spend their artistic life painting this one subject in its infinite variations.

Being hollow, bamboo symbolises the tranquillity of inner peace, when one is empty of worldly concern. Bending with the wind and snow, it does not break but returns to its upright position when the wind and snow stop. Thus it combines flexibility with honesty, with the quality of remaining true to its principles. While bamboo appears throughout the year, with its quick growth and abundant, lush green leaves, it represents the season of summer.

FIG. 1 Load a white-haired brush with water, then with a generous amount of light grey, and tip the last quarter of the hairs with black ink. Holding the brush at the lowest angle possible while still keeping

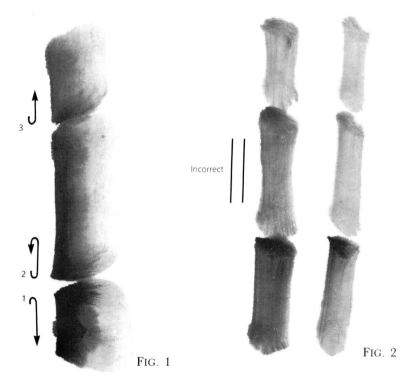

Incorrect

FIG. 1

FIG. 2

the handle off the paper, paint the stem sections, using the hard bone stroke described on p. 12.

Begin with the lowest stem section. This is painted downwards and is fairly short.

Finish all sections with a round end, by pulling the brush around and back over the stem at the finish of the stroke.

The middle section is painted upwards and is the longest.

The top section is the shortest. In a painting, this would extend off the page as if more were growing above.

Add a second stem, raising the angle of the brush to create a thinner stroke, but **not** as in Fig. 2, which illustrates several faults: not only are both stems of the same width as well as being parallel, but also the nodules are on the same level and each section is of the same length. All this creates a regular pattern that makes the composition static.

FIG. 3 This is a more dynamic arrangement of two stems and a third young shoot (host, guest and servant).

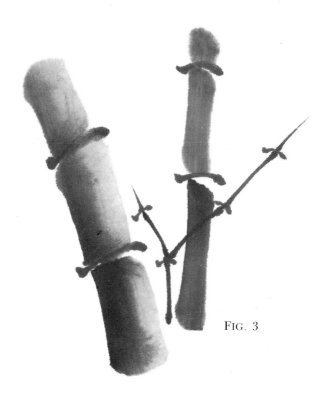

FIG. 3

FIG. 4 Emphasise the nodules with a dark bone stroke painted with an upright red-haired brush, as in the character for *one*. Any variant of this is acceptable, as long as it is consistent throughout the picture.

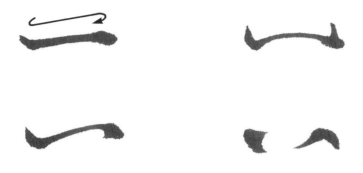

FIG. 4

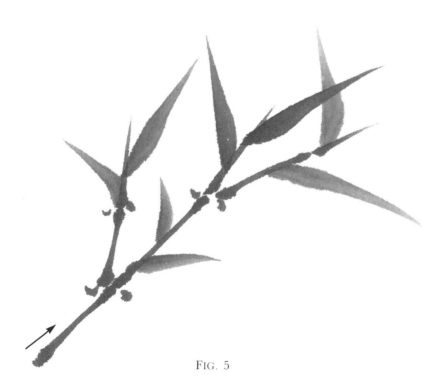

FIG. 5

FIG. 5 For the branches, load a red-haired brush with water, then with medium dark ink. Holding the brush upright, paint the main branch from the bottom upwards. Then add the side branches. Make the last stroke of each branch end in a point by slowly lifting the brush off the page as you approach the end, following through as in a tennis or golf stroke.

To paint the young leaves, use the same red-haired brush loaded first with medium grey ink and then tipped with black ink. After each leaf, re-tip the brush with black ink.

For this exercise, make sure the leaves are attached to the stem. Holding the brush upright, paint from the stem out. Place the tip of the brush on the paper, press down, and then pull the brush along, all the time lifting it gradually until you lift it off the paper. Even when the brush has left the paper, continue to follow through to achieve a sharp finish.

FIG. 6 Paint the older leaves with a sharp, extended stroke, as in the practice section (p. 12). By placing the point of the brush down at different angles, you can start the top of the leaves in a variety of ways. Bring the hairs to a point before starting, and don't twist the brush.

FIG. 7 Five leaves commonly grow together and form a pleasant arrangement. Start with the centre leaf, then paint one on either side, and finally the back two, giving each its own character through its shape, size and direction. Keep all the leaves in one group of the same tone.

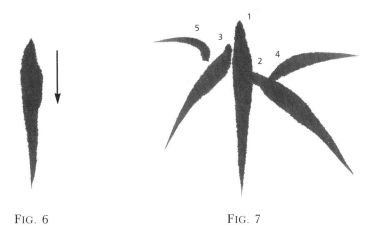

FIG. 6 FIG. 7

FIG. 8 But **not** like this, with all leaves in the same direction and of the same length—this creates too static a pattern.

Incorrect

FIG. 9 And **not** like this either, where three leaves meet each other, creating a point that draws too much attention. Also, avoid having two leaves starting from the same place.

Incorrect

FIG. 10 Two well-balanced leaf groups.

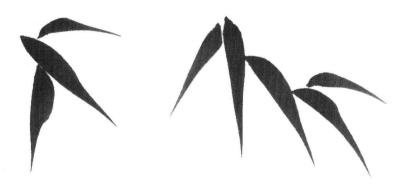

FIG. 11 To make a pleasing composition, place the stem distinctively to one side, and keep the leaves in one area — a mass of dark tones balanced by an empty space in one section of the picture. The branches extend from the stem first from one nodule on the right side, then from the next nodule on the left side, alternating up the stem — this applies to branches as well as leaves.

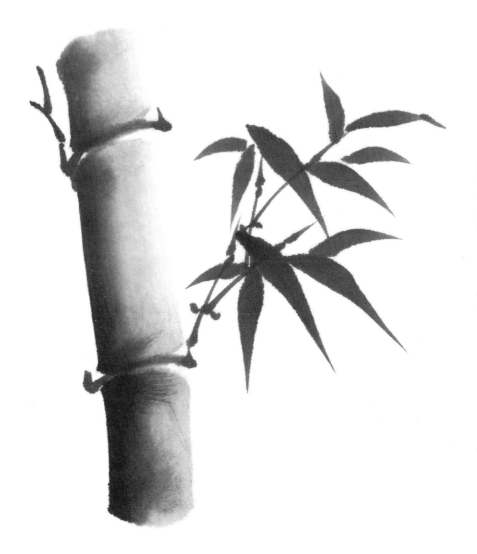

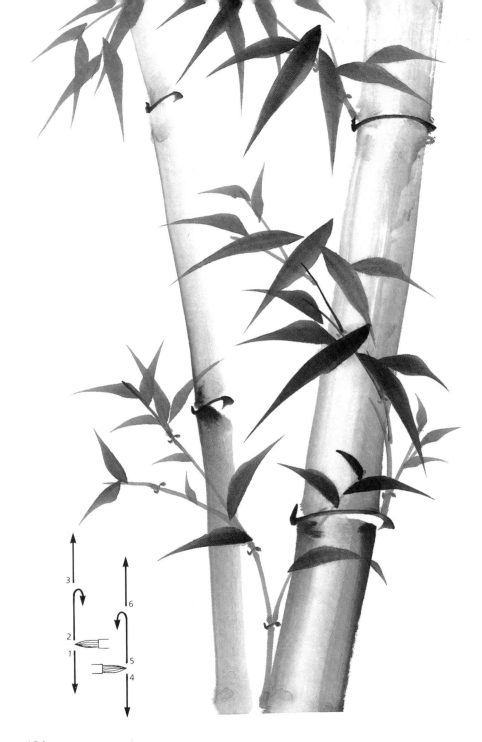

Now try the composition on the facing page.

Stems: Load a white-haired brush with water, then halfway up with green and the last quarter with black. To paint the large, double-sided stem, first paint an ordinary thick stem. Then, after reloading the brush in the same manner, paint another stem beside it but this time holding the point of the brush in the opposite direction, so that the inside light-toned edges overlap to create one very wide stem (see diagram at left). Then retip the brush in black and paint a narrower stem, and finally, a young, short stem. (Again, the relationship is that of host, guest and servant.)

Nodules and branches: Use a red-haired brush loaded with green and tipped with black.

Leaves: Load a red-haired brush with green and tip the last quarter with black. Paint all the older, hanging leaves without reloading the brush, so that the tones will vary. Reload the brush for the younger, upright leaves.

For the composition of young bamboo shown below, use a red-haired brush throughout.

Stems and nodules: Use dark ink.

Leaves: Load the brush with light grey and then add thick black ink to the last half. Paint as many leaves as possible without reloading the brush, to achieve varying tones.

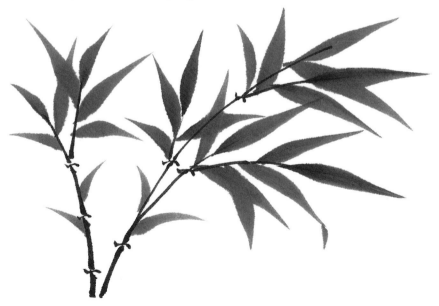

The composition on the facing page combines bamboo and plum blossom.

Stem: Load a white-haired brush with water, add green to half the brush, and tip the last quarter with black.

Nodules and branches: Use a red-haired brush loaded with green and tipped with black.

Leaves: Load a red-haired brush with green and tip the last quarter with black. Paint all the older, hanging leaves without reloading the brush, so that the tones will vary. Reload the brush for the younger, upright leaves.

- Add the plum blossom, using the colours given on p. 28.
- Paint the branch, the flowers, then the details.
- Use purple for the calyx and stamens.

Use the same colours given above, as appropriate, for the composition of young bamboo below. Try to capture the dance of the leaves in a sudden breeze, like startled birds about to take flight.

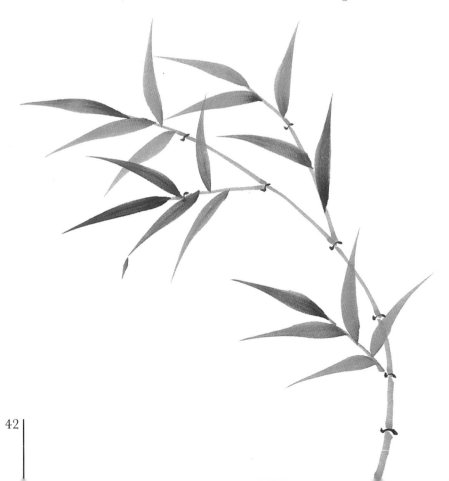

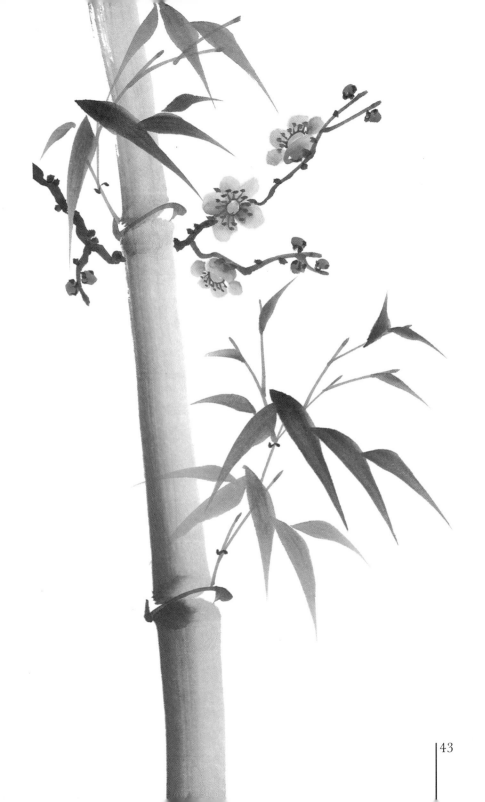

For this composition, first paint the rock in contour style, using a white-haired brush loaded with dry black ink. (If necessary, pat the brush on a piece of cloth to absorb excess moisture.)

- Paint the rock in the order shown (at right), using a bone stroke. Work quickly, holding the brush at an angle of 45°, to create the effect shown, which is called "flying white".
- Add the interior texture strokes, and then a medium grey wash to help form the various surfaces.
- Add the bamboo, the stems first and then the leaves.

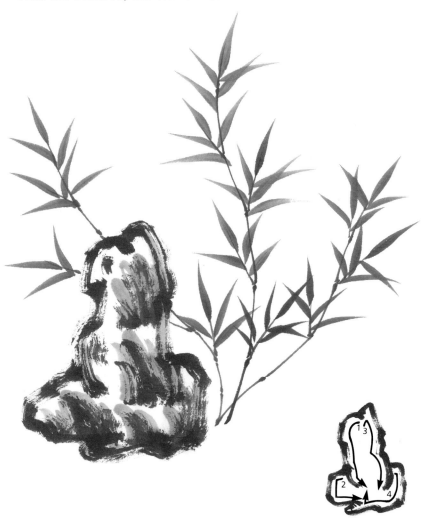

Here is a much more involved composition to try.

- Begin with the two front bamboo stems; then add their leaves.
- Paint the contour lines of the rocks, first in the foreground, then in the background, and then in the waterfall.
- Add the background bamboo, using a fairly regular leaf pattern.
- Apply the grey washes.
- Paint the water strokes with a red-haired brush loaded with a medium tone, using a soft orchid leaf line.
- Finally, add the foliage dots in black when the grey wash is almost dry.

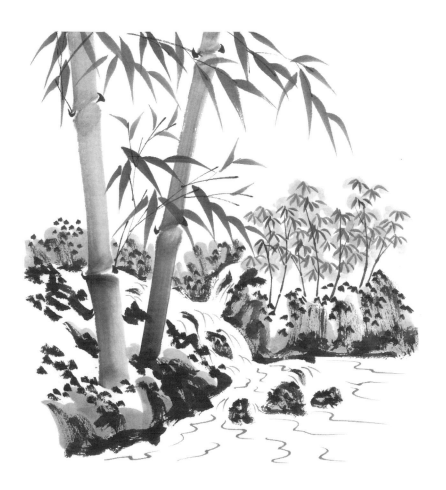

CHRYSANTHEMUM—Autumn (Courage)

Being one of the year's last flowers, the chrysanthemum maintains courage in the face of cold winds and early snows. In painting this flower, you will be drawing upon all the techniques you have learnt so far.

FLOWERS

FIG. 1 Load a red-haired brush with light grey ink, adding a little thick black on the tip. Begin the stroke thinly; then, by adding more pressure, thicken the stroke in the middle; and, lifting the brush slowly off the page, finish thinly again.

FIG. 2 Add more petals in the same way as for an orchid flower (p. 16) but making the petals more uniform.

FIG. 3 Keep adding petals from the tip to the centre until you have a very full flower head.

Add the calyx in short, dark strokes. The stem begins heavily at the base of the flower and is similar to a curved bamboo branch stroke. Use a medium dark ink for this. Finish thickly, to fix it into the ground.

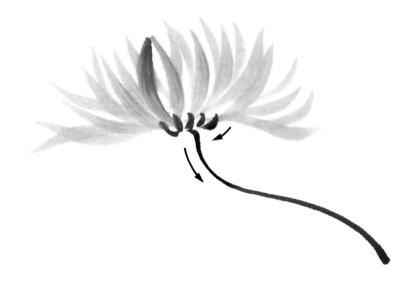

LEAVES

Load a white-haired brush first with water, then with medium grey on half the brush and thick black on the last quarter.

FIG. 4 Begin the stroke thinly, and when it is the desired length, lay the brush down on the base of the hairs to create a rounded stroke like a teardrop. This forms the centre lobe of the leaf.

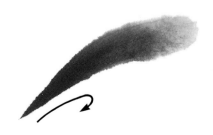

FIG. 5 Add two smaller strokes at the bottom of the leaf, above the stalk, one on either side.

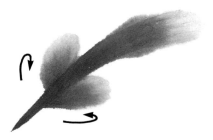

FIG. 6 Add two more strokes in the middle, one on either side, to make a five-lobed leaf, shaped as in Fig. 7.

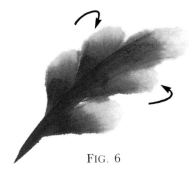

FIG. 6

FIG. 7

FIG. 8 Paint the bud first, slightly darker than the main flower. After painting the calyx and stem, add the lower leaves, making them large enough to balance the bigger flower. These leaves are painted from the stem out; the small new leaves near the flower are painted towards the stem.

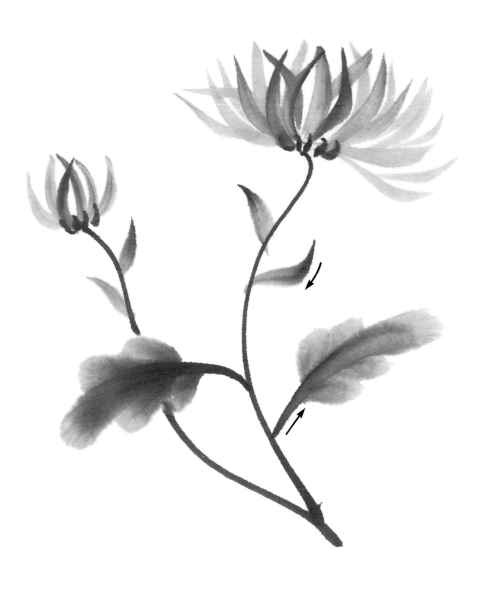

Now try these compositions. In both cases, paint the chrysanthemums first.

The flower below is a variation on the technique described on the previous pages. For this effect, use the teardrop stroke shown on p. 12 (Fig. 13).

Flower: Load a white-haired brush with water, then with purple half-way up the brush, and tip with red.

Calyx, stem: Load the brush with green and tip with black. Paint with the brush upright.

Leaves: For the large leaves, load the brush with green and tip with black. For the medium-sized leaves, load the brush with green and tip with indigo. For the young leaves, load the brush with yellow/green and tip with red.

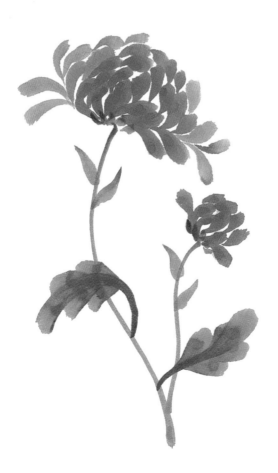

The technique of painting the butterfly is explained on pp. 56–7.
Body: Load a red-haired brush with green and tip with brown.
Wings: Load a white-haired brush with water, wipe off the excess, add yellow halfway up the brush and tip with red.
Eyes, antennae: Load a red-haired brush with brown and tip with a little black.
Wing markings: Load a red-haired brush with red and tip with a little purple. Add the markings when the wings are almost dry.

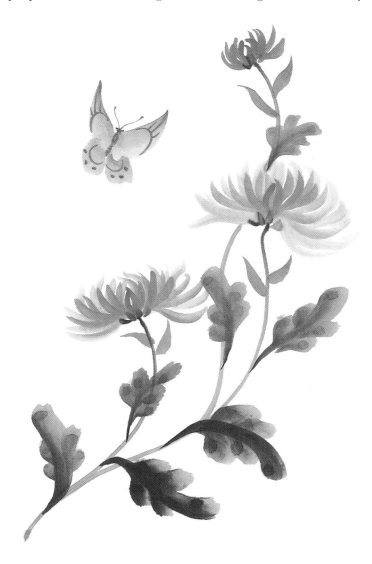

All the contour flowers in this book are done with medium grey bone strokes.

- First paint the centre foremost petal with two strokes.
- Working out from this, add the front layer of petals, then the second layer, then just the tips of the back layer. Paint these strokes from the base of the petal to the tip.
- Complete the chrysanthemum as shown previously.

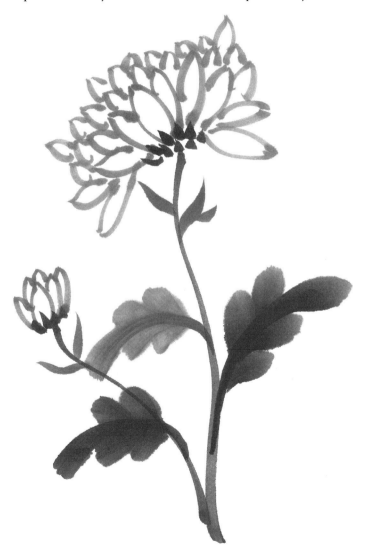

For this composition:

- Begin with two bone strokes to form a circular centre.
- Add the inner circle of petals, followed by a second layer. Add the third layer just on the underneath section (as shown), to make the flower face in the required direction.
- Add a ring of dark dots to form the face of the flower.
- Add the leaves as shown in the diagram on p. 54.

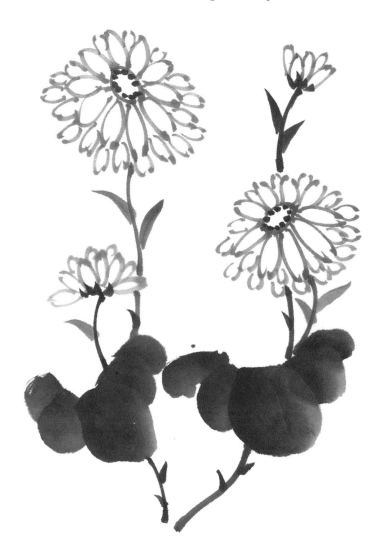

Now try the composition opposite. Paint the bamboo first.

Stem: Load a white-haired brush with water, then halfway up with green, and tip with black.

Nodules, branches: Load the brush with green and tip with black. Paint with an upright brush.

Leaves: Load the brush as for the stem. Paint all the leaves without reloading the brush to achieve varied tones of green.

Now add the chrysanthemum.

Flower: Load the brush with water, then halfway up with yellow, and tip with red. Paint the bud first.

Stem and calyx: Load the brush with green and tip with black.

Leaves: Paint the large leaves as shown in the diagram below, loading the brush with green, tipped with black. For the young leaves, load the brush with a lighter green and tip with red.

Other details: Add ground moss dots, using a white-haired brush loaded with green and tipped with black. Holding the brush at an angle of 45° and pointed away from you, lay the tip of the brush down first, press down and lift back up over the stroke.

Add grass, using a small stroke like that for the orchid leaf.

To paint the spider chrysanthemum shown below, use the bone stroke, beginning at the centre of the flower and hooking back at the tip of each petal. This is very similar to the bamboo nodule stroke in Fig. 4 on p. 36, especially the example at bottom left.

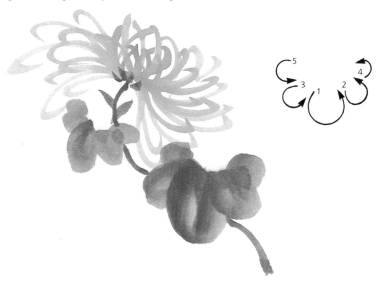

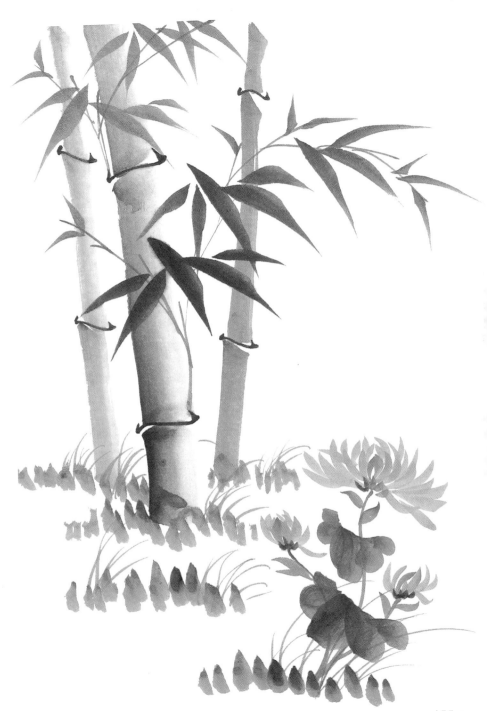

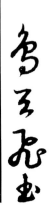

BIRDS AND INSECTS

Birds and insects can be added to your compositions, as long as they are in keeping with the season and the subject. For example, a butterfly can be combined with most flowers, but not with bamboo or a bird (never put birds and insects together); a dragonfly with a waterlily or iris, but not with a peony.

INSECTS

An insect's body has three parts: head, thorax and tail. The legs and wings emerge from the middle section.

BUTTERFLY
Use a white-haired brush for the body and wings.

FIG. 1 Paint the head in medium grey tipped with black, using a small dot as for the plum blossom petal.

FIG. 2 Add an elongated, rounded body.

FIG. 3 Finish with a longer tail that comes to a short point. Paint all the body without reloading the brush, as if in one movement.

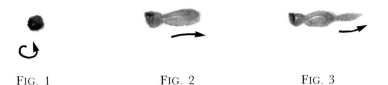

FIG. 1 FIG. 2 FIG. 3

FIG. 4 Load the brush with water, then with light grey, and tip with black. Paint the top front wing first. From the tip of the wing towards the body, use a wider but similar stroke, as for small chrysanthemum leaves. Then add the lower front wing.

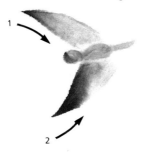

FIG. 5 Paint the back wings with the brush loaded as for the front wing, but this time paint from the body outwards in a single, curved stroke.

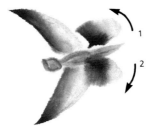

FIG. 6 Add the details, using a red-haired brush loaded with dark ink.

Paint the antennae, starting at the tips and finishing at the head of the butterfly.

Add wing markings, if desired, using a medium tone of ink, just before the wings are dry. If the wings are too wet, the markings will blur.

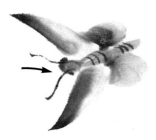

DRAGONFLY

FIG. 7 Paint the head and body as for the butterfly, and then do a tail with a series of dots, finishing in two thin strokes.

FIG. 8 Add the wings from the body outwards. Do the front wings first and make them longer, pressing the brush down slightly before lifting it clear of the paper to create a rounded end to the wings. Add the feet and face details in dark ink.

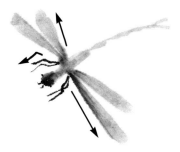

FIG. 9 A side-view of a hovering dragonfly — note that neither all the wings nor all the legs are included, for simplicity.

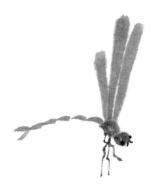

Now do the grasshopper.

FIG. 10 Paint the head with a small downward dot.

FIG. 11 The body is two long, rounded strokes.

FIG. 12 The tail is short and tapers away.

FIG. 13 Paint the underneath part in light ink, with the thickest part under the "chest" (not under the "abdomen").

FIG. 14 Paint the legs coming from the body in bamboo-joint strokes. The back pair of legs is much thicker. (Insects have six legs, but painting only four or five will give a better effect.)
 Add the eyes and antennae last, in darker ink.

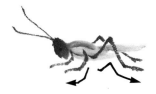

Paint the orchid flower first.

Flower: Load the brush with water, then halfway with red and tip with purple. Paint all the flowers without reloading the brush. The bottom flowers should be very faded.

Stem: Load the brush with yellow/green and tip with brown.

Centres: Dark purple.

Then paint the leaves, from the longest to the shortest.

Now do the grasshopper.

Body: Load a white-haired brush with yellow/green and tip with cobalt blue. Paint the head, body and tail without reloading the brush.

Underneath: Load a white-haired brush with water, remove the excess on a cloth and tip with red.

Legs, antennae: Use a red-haired brush loaded with yellow/green and tipped with cobalt blue.

Eyes: Deep red.

BIRDS

Use a soft, white-haired brush for the body.

FIG. 1 With the brush loaded with medium grey and tipped with black, begin from the top of the head with the same movement as for the chrysanthemum leaf stroke.

FIG. 2 Add two similar, slightly larger strokes to form the wings, starting from the neck. Make the wings grow from the shoulders.

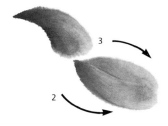

FIG. 3 Add the tail from the base of the body. Try to do all these five strokes without reloading the brush.

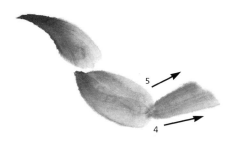

FIG. 4 For the underbody, load the brush with light ink and tip with medium grey. Holding the brush at an angle of 45°, place the point at the beginning of the head and paint a stroke similar to an orchid leaf, lifting the brush to create the neck, then pressing down again to form the breast, tapering the stroke towards the tail.

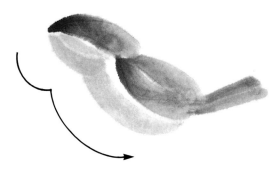

FIG. 5 Add the details in very dark ink, using a red-haired brush. Make sure the feet extend from the base of the body. Place the eye in line behind the beak. Do a dark, hooked stroke to emphasise the wings.

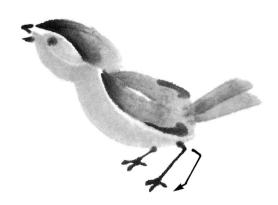

FIG. 6 When painting two birds, do the one on the left completely first. This makes it easier to place the second one in proportion. Paint the underbody of the two birds in two separate strokes, similar to orchid petals.

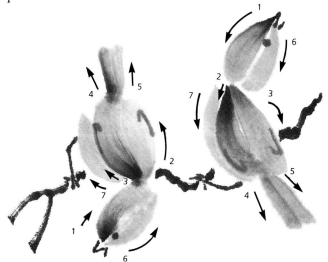

FIG. 7 To paint the chicken, use a white-haired brush loaded with a very light tone of ink and tipped with a little black to create a soft, fluffy body. Just a short line is needed to round the head. Make sure the feet are well spread, to keep the body balanced.

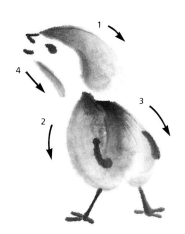

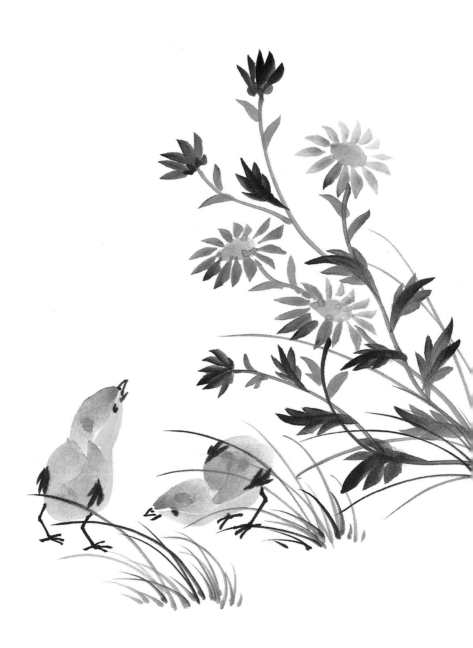

Paint the daisies first.

Centre of flower: Place a dot, using a white-haired brush loaded with yellow/green and tipped with cobalt blue.

Flower petals: Load a red-haired brush with water, then halfway up with cobalt blue, and tip with purple. Paint the bud first, then the petals of the main flower from the tip to the centre — starting with the petals in front, work left and right alternately, towards the back (see diagram).

Calyx and stem: Use a red-haired brush loaded with green and tipped with brown.

Leaves: Load a red-haired brush with green and tip with black. Paint all leaves from tip to stem. Do the centre strokes first, then add the side lobes. Paint the leaves without reloading the brush.

For the young, small leaves, tip the brush with red instead of black.

Now add the chickens.

Bodies: Load a white-haired brush with water, then three-quarters full of yellow, and tip with red. Paint the body strokes slowly, to create a soft, fluffy appearance.

Beaks, eyes, wings, legs: Use a red-haired brush loaded with black ink. The body should be almost dry before you add eye and wing markings — if the body is too wet, the strokes will run, and if the body is too dry, they may stand out too harshly.

Finally add the grass, which should all move in the one direction.

The movement in this composition comes from the direction of the chickens and the attitude of the flowers.

TRADITIONAL CHINESE FLOWERS

When combining flowers, remember to keep to flowers of the same season; for example, a camellia with plum blossom (winter), but neither of these with a peony or waterlily (summer). (Bamboo goes with everything, as it grows throughout the year.)

CAMELLIA

The camellia symbolises the serenity of winter. First paint the flower, using a white-haired brush.

FIG. 1 Paint a light grey circle for the flower centre.

FIG. 2 With the brush loaded with light grey, with just a tip of black, do the petal closest to you — a large plum blossom stroke. Paint a second petal, overlapping the petals slightly. After the front two petals, add the back petal, as this makes it easier to add the last two petals symmetrically. Keep the tip of the brush towards the centre of the flower, and rotate the base of the hairs in a circle.

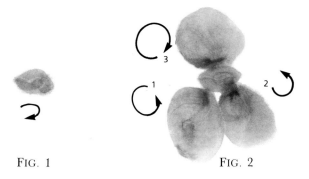

FIG. 1 FIG. 2

FIG. 3 The finished flower, with five petals. The leaves are painted next, as these dominate the composition more than the branch.

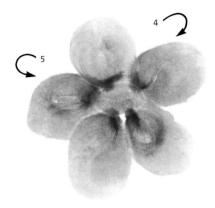

FIG. 4 Load a red-haired brush half with medium grey and a quarter with black to produce glossy, dark leaves. Lay the brush on its side and paint a thick, curved bamboo leaf stroke.

FIG. 5 The other half of the leaf is done with a similar stroke but curved in the other direction; only one of the halves needs to finish in a point. If there is a gap in the middle of the leaf, just fill it in at the end of the second stroke.

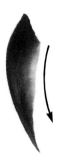

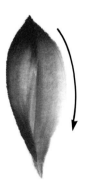

FIG. 4 FIG. 5

FIG. 6 Flowers — the host; leaves — the guest; branch — the servant; add details — moss and stamens.

A The bud should be slightly darker than the flower. Use a sideward stroke, and a similar stroke, but smaller and darker, for the calyx.

B Paint the stem with dark, wet ink to suggest more flexibility than in the branch, using a curved bamboo branch stroke.

C Do the centre leaf in each group first (1), then alternate leaves on the right and left sides (2) and (3). Add the underneath ones last (4), as in bamboo leaf groups.

D Add smaller, young leaves, pointing up.

E Do the branch as for the plum blossom (p. 24).

F Do one tall stamen in the centre and a number of shorter ones, grouped around the central stamen. Use the darkest black, to suggest vitality.

G Add moss, using a dark, short, square stroke.

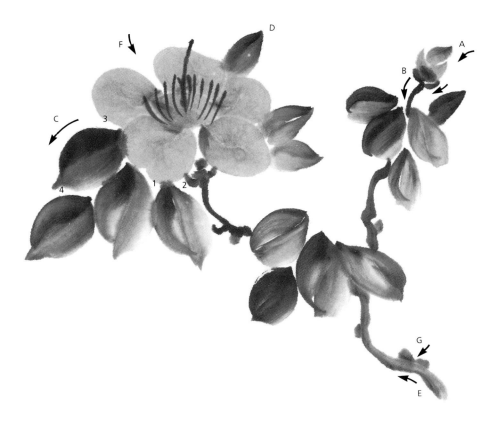

MAGNOLIA

Magnolia leaves usually appear only after the flowers have fallen, but a few early ones can complement the flower.

Paint the flower first. As always when painting flowers, begin with the petal closest to you. Load a white-haired brush with water, then halfway up with light grey, and tip with thick black.

FIG. 1 This is painted like a short, fat orchid leaf stroke, with the brush held at an angle of 60°. Place the brush tip on the paper first, pull it towards you, apply more pressure to create the thick part of the petal, then lift the brush at the end of the stroke to finish on the tip.

FIG. 2 Do a second stroke in mirror image to make a full petal (similar to the bird's body).

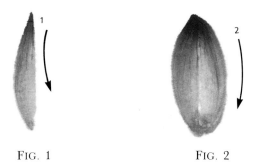

FIG. 1 FIG. 2

FIG. 3 For each side petal, do only one wide stroke. Using a fine stroke and an upright brush, paint the outer edge of the petal, forming a white inside.

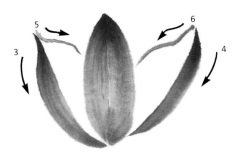

FIG. 4 Complete the back petals with a fine stroke for each edge, starting thick and fading away like a rat's tail. Begin each petal from the top, making sure that if the flower were closed again, the tips would meet, as in the bud. Add the calyx with a brush loaded with dark black, using a smaller version of the petal stroke.

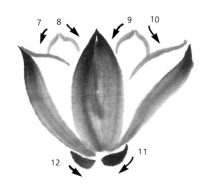

FIG. 5 Using a red-haired brush loaded with light grey and tipped with black, add the leaves. Start from the branch. Holding the brush upright, paint the stem; then, with the brush still on the paper, lay the brush down to an angle of 45° and paint as you would a bamboo leaf.

FIG. 6 Add a second stroke beside this to make a wide leaf. (Only one of the strokes has to make a point.) If a gap appears in the middle, fill it in with a third stroke. (The same applies to the flower petal.)

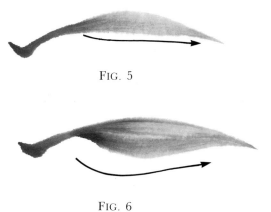

FIG. 5

FIG. 6

FIG. 7 The completed composition.

A Paint a bud darker and tighter than the flower. Then do the flower.

B Next add the branch. Starting from the bud, use a stroke similar to that for the plum blossom branch but darker. Make the branch wider as it reaches the main trunk (which is not shown). Allow the flower to overlap the branch, as shown, to create depth in the composition.

C Add moss in dark, round dots, placing it so that it breaks up an otherwise long, empty branch.

D The magnolia is a shy flower — the centre is seen peeking round the edge of the petal. Use sharp, dark strokes for the centre.

E Paint the leaves from the branch outwards.

F Add the bee last.

- In medium-tone ink, do a small, round dot for the head.
- A longer, round body.
- With lighter ink, two quick dots for the wings.
- Use a fine-vein brush and dark ink for the details: legs, eyes, stripes.

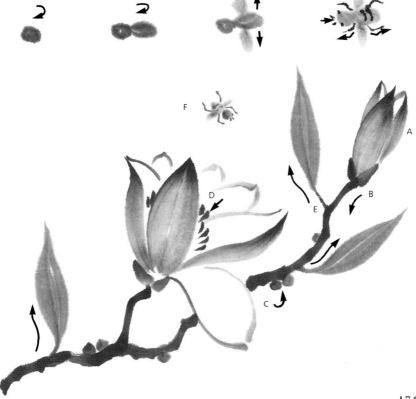

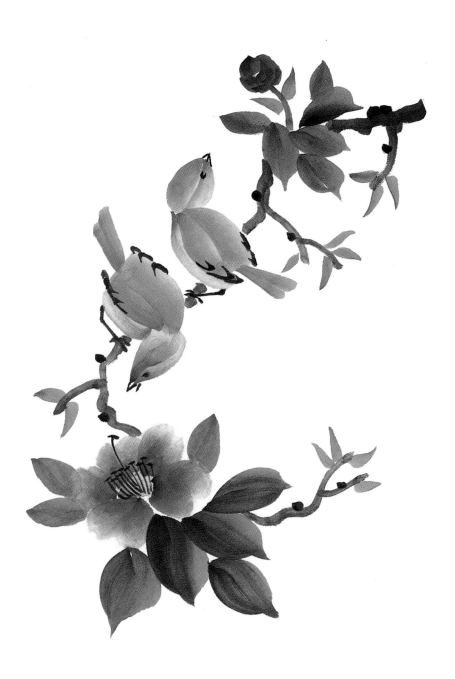

For the composition opposite, first do the birds, as described on pp. 61–3.

Birds
- Light green tipped with light blue for the heads.
- For the underbodies, load the brush with water, wipe off the excess, and tip with light red.
- Black ink for details: eyes, wings, legs. One bird's beak is open, one closed, for balance.

Flowers
- The centre of the flower is painted in light green tipped with blue, echoing the birds' bodies.
- For the petals, load the brush with water, then halfway up with red, and tip with purple. Work quickly, to prevent the water from spreading too far.
- Use dark green tipped with black for the old leaves.
- Use medium green tipped with red for the large, young leaves.
- For the branch, load the brush with burnt sienna mixed with a little black and tip with thicker black.
- The small young leaves are light green tipped with red, painted in one stroke towards the branch.

To paint the contour-style camellia shown below:
- Begin with two bone strokes to form the centre of the flower.
- Add five petals, similar to the plum blossom.
- Complete the composition as shown previously.

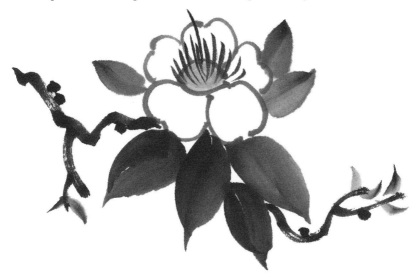

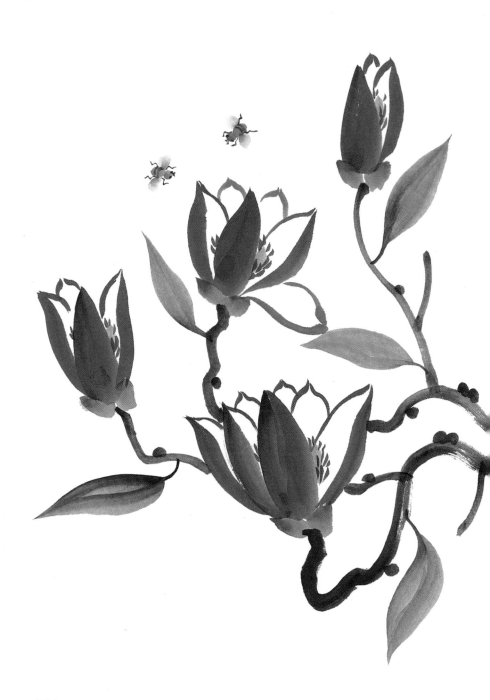

Here are two compositions to try.

Flowers: First load the brush with water, then halfway up with a mixture of red and cobalt blue (to make purple), and tip with red. Note that for the flower on the facing page, the red is mixed with a little black to strengthen the tone. Paint the buds first; then paint the flowers. Paint each flower without reloading the brush to get the effect of the more faded back petals.

Calyx: Load the brush with yellow ochre and tip with burnt sienna.

Branch: Burnt sienna mixed with indigo, the brush then tipped with black. Be aware of the spaces formed by the branches, as this gives structure to the composition.

Leaves: Medium green tipped with black. For the young leaves, tip the brush with red instead of black.

For the bees:

Bodies: Yellow and burnt sienna, echoing the calyx.

Wings: Use a water-loaded brush almost dried out, with just a trace of light blue on the tip. Work very fast, to stop water spreading on the rice paper. Keep the tip of the brush pointed towards the body.

Details: For the stripes, eyes and antennae, use a mixture of burnt sienna and indigo.

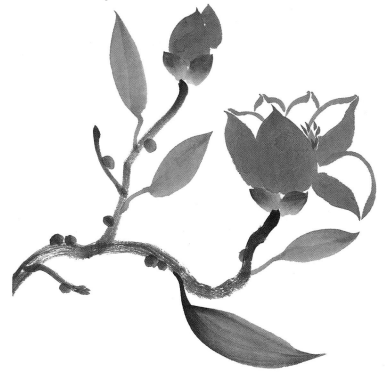

IRIS

Use a white-haired brush to paint the flower, first loaded with water, then with light grey, and tipped with dark black. Try to paint the whole flower without reloading the brush.

FIG. 1 Paint three inner petals with short, downward strokes.

FIG. 2 Add the front petal in two strokes, pointing the tip of the brush towards the inside of the petal to create a soft, light edge. From the centre of the flower to the tip of the petal, wiggle the brush as you pull it down to create a crinkled edge, rounding off the stroke at the tip of the petal. When adding the second stroke, leave a white gap at the base of the petal.

FIG. 3 Make the two side petals slightly smaller, as they are further

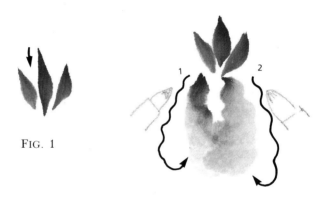

FIG. 1

FIG. 2

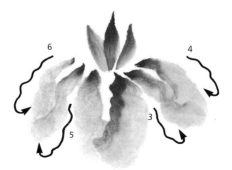

FIG. 3

FIG. 4 Add the calyx, then the stem, in medium dark grey. Make sure the stem is thicker at the base of the flower to support the flower head.

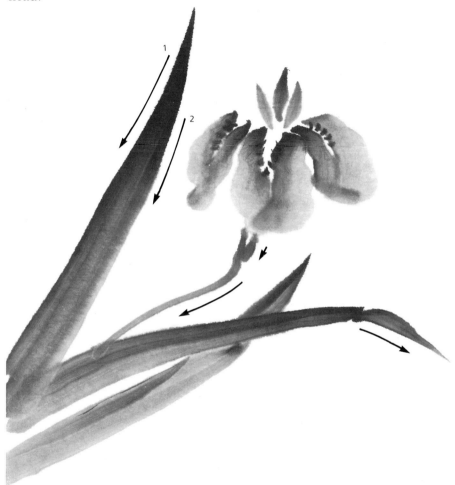

With a red-haired brush loaded with medium grey and tipped with black, paint the leaves in two strokes beside each other to make a wide leaf. Start at the tip of the leaf, holding the brush upright; as you pull the brush down towards the edge of the paper, slowly lower the angle to 45°. Add a twist on the end of the third leaf with a single bamboo leaf stroke.

Add the stamens on the white of the flower petals, using small, dark, pointed strokes.

Now try these two irises.

- **Flower** Load the brush with water, then with cobalt blue, and tip with purple. In two strokes, paint the bud; then paint the flower — this will make the bud darker, which makes it look firmer. Add the flower markings in cobalt blue while the flower is still slightly wet.
- **Stems** Medium green.
- **Leaves** Paint the longer leaves with a medium green brush tipped with black. Paint the younger leaves with a green brush tipped with red.
- Give the plant a wide base.

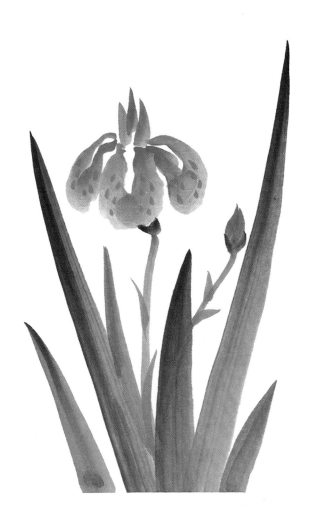

For this painting:
- Add dots in burnt sienna, tipped with black, to create the water's edge.
- To complement the plant, add a dragonfly in alizarin crimson.

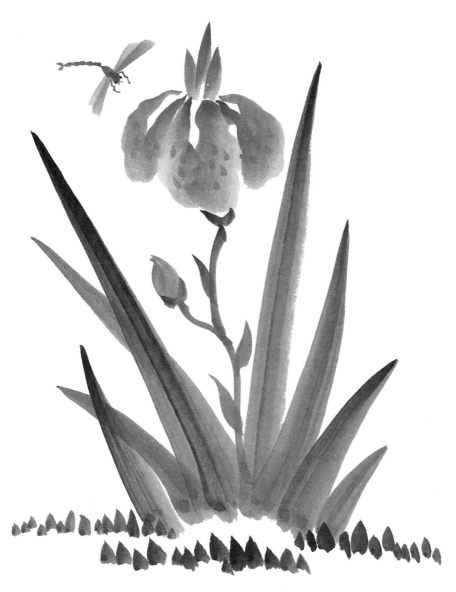

MORNING GLORY

Begin with the flower. Load a white-haired brush with light grey and tip with a little black.

FIG. 1 The first two strokes are like orchid petal strokes, except that you hold the brush at an angle of 45° instead of upright. Start thin, press to make thicker, lift up to thin again.

FIG. 2 The three back petals are painted like the head of a bird. Start thin, then lay the brush down and pull it around to create a teardrop finish.

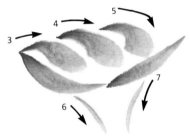

FIG. 3 The leaf also is painted with the white-haired brush, loaded first with medium grey and then with black on the top third. Paint it like a camellia leaf, but make the end round instead of pointed.

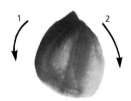

FIG. 4 Add the smaller side lobes of the leaf, using two strokes for each. Position the leaf below and to one side of the flower.

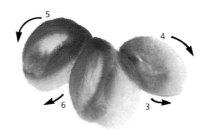

FIG. 5 Using a red-haired brush, add the calyx and the centre of the flower with dark, downward strokes. Add the stem and the vine, holding the brush very upright to maintain an even thickness of line. Don't make the twists in the vine too regular, but allow the vine to wander through the composition.

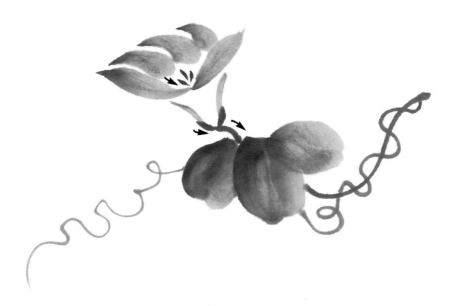

- **Flowers** Load the brush with plenty of water, then pick up cobalt blue to halfway up the brush. Add purple mixed from alizarin crimson and cobalt blue to the tip of the brush. Paint the buds from the top in three downward strokes.
- **Leaves, calyx and stems** Medium green tipped with thick black ink.
- **Stamens** Yellow tipped with red.

 Study and try to capture the rhythm of the composition on the facing page, which comes mainly from the placement and direction of the flowers.
- Add the butterfly last. Paint the wings with a white-haired brush loaded with water and tipped with a little orange. Paint each wing as you would a plum blossom petal, keeping the tip of the brush towards the butterfly's body.
- Add the markings in light orange when the wings are almost dry, painting thin needle strokes out from the body.
- Give a darker edge to the wings, using orange mixed with a little brown.

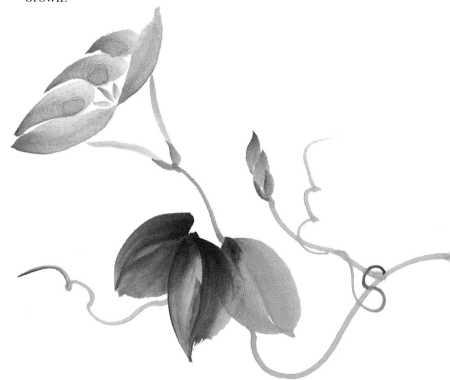

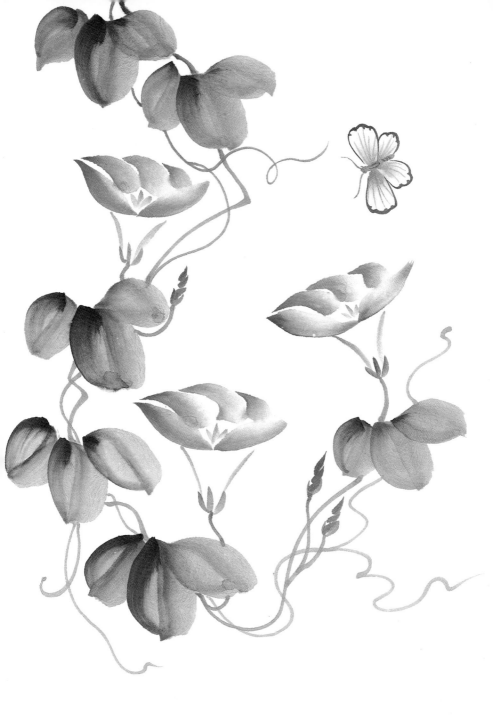

MORE ABOUT BIRDS

To create life within a bird, you must give it the appearance of being about to take flight. This can be achieved by turning its head or by leaning its body at a sharp angle across the branch. The hardest angle to paint is the front of a bird.

Load a white-haired brush with light grey and tip with black. Paint from Fig. 1 to Fig. 3 without reloading the brush.

FIG. 1 Paint the head with one stroke, like a cap.

FIG. 2 Add a wing in a thin, thick, then thin stroke. Add the tail, thin to thick.

FIG. 3 Holding the brush upright, paint three thin lines to delineate the chin, breast, and tail edge.

FIG. 4 Using a red-haired brush loaded with black ink, add the details: beak, eye, wing markings, feet. Write these strokes clearly, to add vitality. Then add the branch.

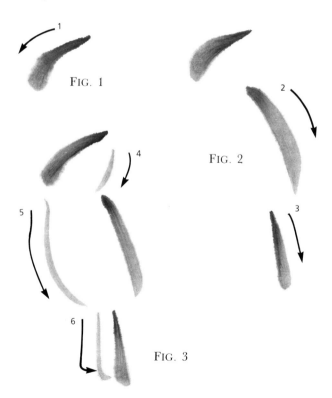

FIG. 1

FIG. 2

FIG. 3

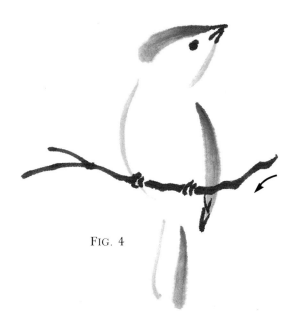

FIG. 4

FIG. 5 Start another bird with a cap-like head facing left.

FIG. 6 Add two wing strokes, then two tail strokes and a chin stroke.

FIG. 7 Add the details in vibrant black strokes. Paint the branch last.

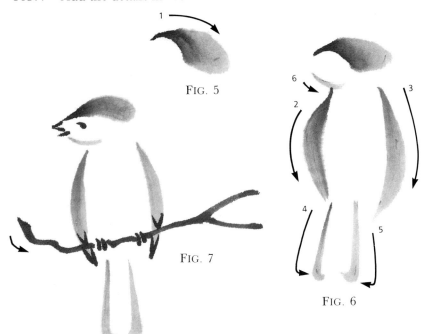

FIG. 5

FIG. 7

FIG. 6

Here are two bird compositions.

- Paint the birds first. Where there are two birds, the task of composition is made easier if you paint the bird on the left completely first, so that it will be in view when you are painting the right-hand bird. This helps you to judge the proportions better.
- To delineate the head and body, load the brush with cobalt blue and tip with indigo.
- Add the beak and eye in black, leaving a white space in the pupil.
- For the face and neck markings, add water to the brush and load with brown mixed with black. Fill in the head, working from the beak to the neck. Allow the colour to be slowly worked off the brush.
- Add the flight feathers and feet in black.
- Add the plum blossom or the bamboo, using the colours given on pp. 28 and 41.

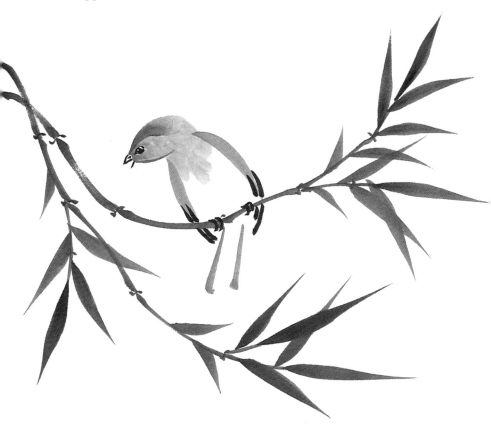

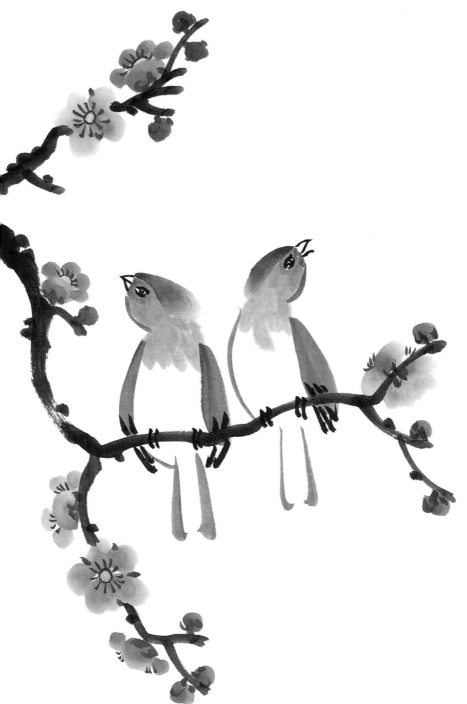

FLYING BIRDS

FIG. 1 Paint the head and body as for a stationary bird (pp. 61–3).

FIG. 2 With a short, thick bamboo leaf stroke (holding the brush at an angle of 45°), paint the foremost wing over the body and upwards.

FIG. 3 Make the back wing smaller. Both wings should grow from the bird's shoulders.

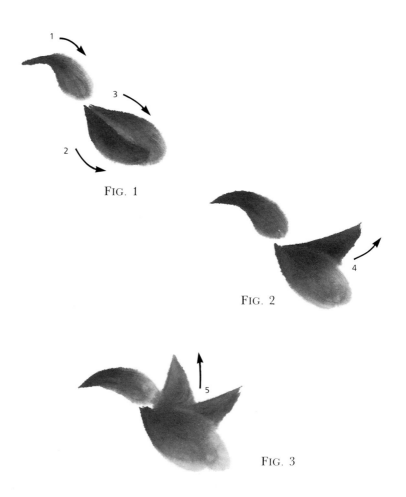

FIG. 1

FIG. 2

FIG. 3

FIG. 4 Add the underbody in light grey, as for a stationary bird.

FIG. 5 Add dark strokes with a red-haired brush to form the flight feathers. Start at the top of the wing, and paint each stroke underneath slightly shorter. Add the tail with similar strokes in a fan shape.

FIG. 6 Add the eye and beak. Add legs only if the bird is about to land or take off; otherwise they are tucked into the body and not seen.

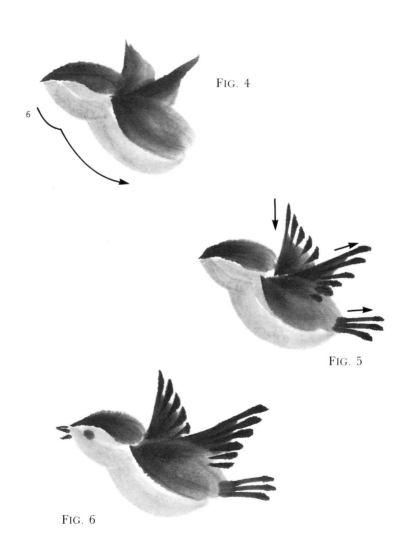

FIG. 4

FIG. 5

FIG. 6

FIG. 7 Paint the foremost wing with a downward stroke to give the bird a different posture (Fig. 8).

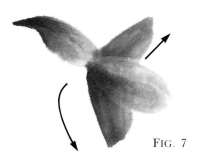

FIG. 7

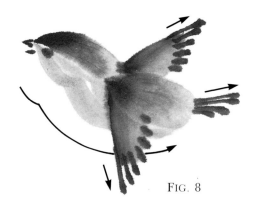

FIG. 8

- Paint the bird on the branch first.
- Burnt sienna tipped with black for the head, upper body and wings.
- A very light red/brown for the underbody.
- Black for the wing and tail strokes.
- Black for the beak, eye and legs.
- Add the bamboo next, using medium green tipped with black.
- Add the flying bird last, using a touch of red for the tongue.

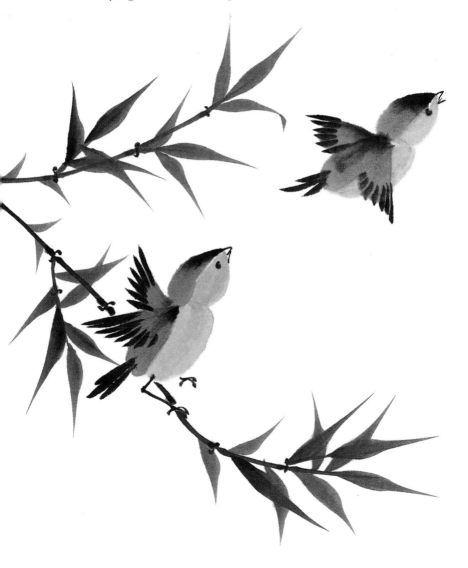

WATERLILY

FIG. 1 Using a white-haired brush loaded with light grey and tipped with black, paint the flower petals in the same way as you would magnolia petals (pp. 69–70), but make them shorter and the base of the flower wider.

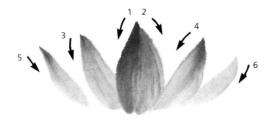

FIG. 2 Add the back petals in single strokes (without reloading the brush).

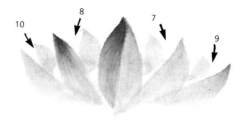

FIG. 3 Load the white-haired brush with medium grey tipped with black to do the leaves. Paint the front of the leaf as you would the first stroke of a bird's body.

FIG. 4 Paint the back of the leaf with a similar stroke, leaving a white V, which is characteristic of this leaf.

FIG. 5 The finished composition. Paint the bud, flower and then the leaves smaller as they recede to create the expanse of water.

Add the calyx and stamens in dark ink, using a red-haired brush. Use the same brush for the water, which is painted in a very light grey, using the soft orchid leaf stroke. The overall pattern of the water should be like a flattened diamond, as in Fig. 6.

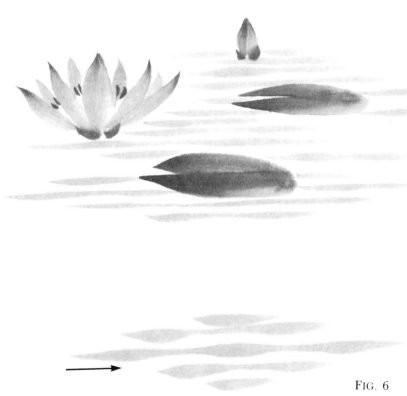

FIG. 6

Now try these two waterlily compositions.

- **Flowers** Below: Load the brush with water, then with red, and tip with purple. Opposite: use orange tipped with red. Do the flowers first, then the buds, which should be slightly darker.
- **Leaves** For the larger, older leaves, medium green tipped with black; for the younger leaves, lighter green tipped with red.
- **Calyx** Medium green.
- **Stamens** Deep red mixed with black.
- **Water** Very pale indigo. For the composition below, paint the water with an orchid leaf stroke.
- Reeds can be added when the water is dry to enhance the composition by introducing vertical lines among the horizontals. They are painted with a red-haired brush loaded with burnt sienna and tipped with indigo. Paint from the tip in single strokes, applying more pressure to create a base wider than the tip. Keep the reeds in groupings.
- A dragonfly could be added. (Cobalt blue would complement the flowers.)

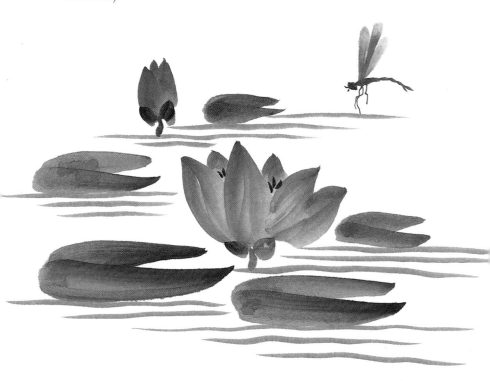

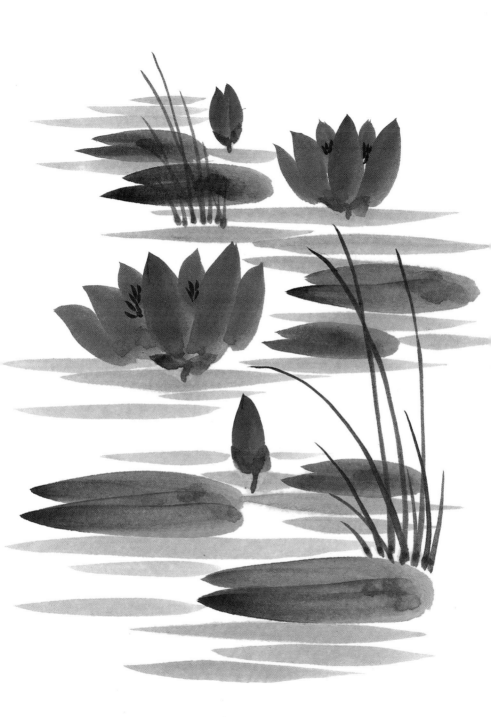

95

PEONY

The peony is an appropriate flower to finish with, as it is considered to be the queen of flowers, signifying wealth and nobility. It is also one of the most difficult flowers to paint, because of its many petals.

FIG. 1 Load a white-haired brush first with water, then with light grey, and tip with black. Paint the inner petals with a stroke similar to that used for plum blossom (p. 25). When adding each petal, don't leave too much white space between it and the previous one; place the petals as close as possible without losing their individuality. To achieve this, keep the tip of the brush pointed towards the centre of the flower, so that the light edge of one petal is met by the dark edge of the next petal.

FIG. 2 Add the next layer of petals, using a larger, elongated version of the plum blossom stroke.

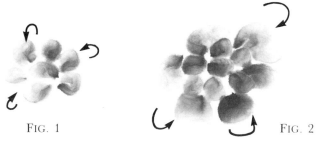

FIG. 1 FIG. 2

FIG. 3 Paint the outer layer of petals with a long, wiggling stroke, like large iris petals. Place fewer petals at the back, to turn the flower head up. Make sure the flower is well proportioned.

FIG. 4 Side view of a peony. Begin with the layer of petals closest towards you, and work towards the back.

FIG. 5 Add the stem first, then the calyx.

FIG. 6 The leaves have five lobes. Using a red-haired brush loaded with medium grey and tipped with black, paint the first section similarly to a camellia leaf.

FIG. 7 Add two smaller side lobes.

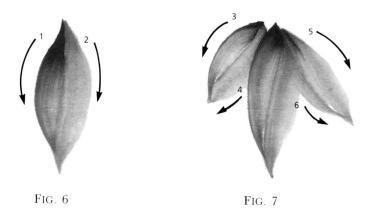

FIG. 6 FIG. 7

FIG. 8 Add two even smaller back lobes. Each lobe or section is made up of two strokes, one of which should be pointed.

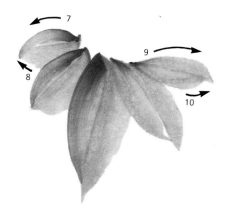

FIG. 9 Paint the flower, then a large leaf. Add the stem in medium grey with a flexible bamboo stem stroke. Add the branch and the young leaves in downward strokes. Add moss, stamens and the calyx in dark ink. Note how the stamens are grouped in threes.

Study the flowers you see around you — the texture and form of the petals, the attitude of the leaves and their arrangement on the stem or branch, the strength of stems and branches. Copying traditional subjects teaches you the fundamental techniques of creating the brush strokes, the use of tone/colour, and how to place your subjects, and this will give you the necessary skills to apply to your own compositions.

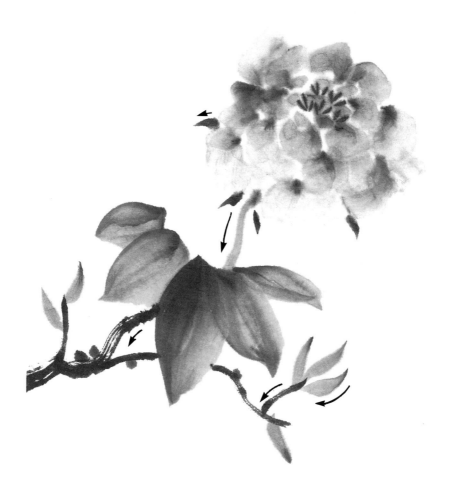

To paint a peony in contour style, each petal is done with a single bone stroke.

- The younger petals have one centre lobe and two smaller side lobes. The older petals are more varied. Begin with the centre petal closest to you, next do the inner layer, then spiral outwards around the front and underneath section and finally towards the back.
- Start the bud with the petal closest to the calyx and then build up the others.
- Paint the stem and leaves as previously described.

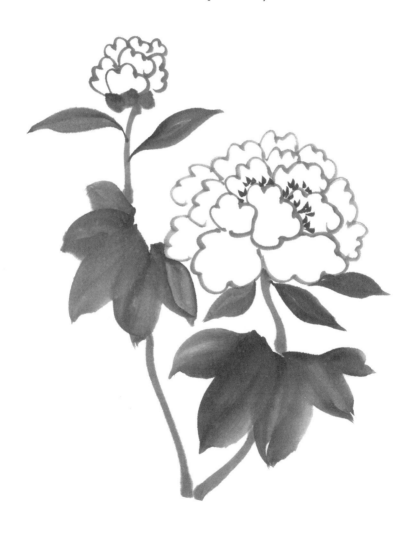

Note the elongated lobes of the leaves in the composition below. In both these compositions, the stems must have strength to support such a large flower. This is achieved by tone, thickness and "bone" (the characteristic of the bone stroke).

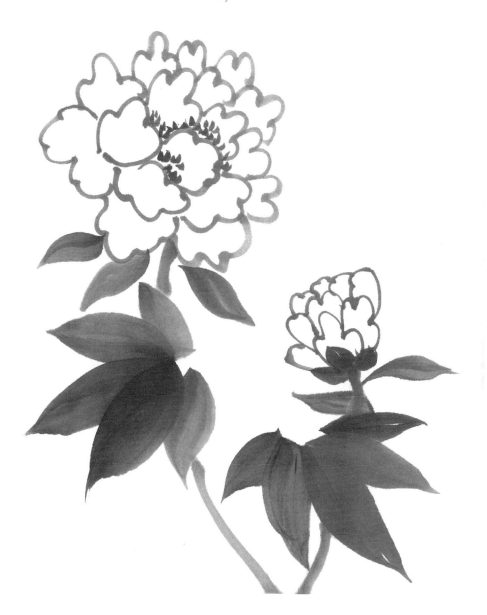

For the best results when painting these compositions, each successive darker colour should be mixed a little thicker (using less water), so that the colours do not merge too rapidly.

- **Pink peony** Load the brush with water, add red a third of the way up the hairs, and tip with purple.
- **Yellow peony and bud** First paint the circular centre of the flower, using light yellow-green tipped with cobalt blue. Next paint the bud. Load the brush with water, wiping off the excess, then add yellow two-thirds of the way up the hairs, red a third of the way up, and tip with purple (see p. 8). Using the same brush, paint the flower. As the colours on the brush are painted out, the outer petals should appear lighter, as if faded.
- **Leaves** Use medium green tipped with black for the older leaves.
- Next paint the stem, branch, moss dots and stamens.
 Stem Medium green tipped with red.
 Branch Burnt sienna tipped with black.
- Using light green tipped with red, paint the younger leaves from the tip to the base in three strokes.
- Add the butterfly last. For the body, load the brush with green and tip with brown. Then, using a white-haired brush loaded with water, halfway up with cobalt blue and tipped with purple, paint the front nearest wing first from tip to body; then the back wing; and finally the other front wing. Add the details with an upright red-haired brush loaded with brown mixed with a little indigo. Paint the wing markings in deep red.

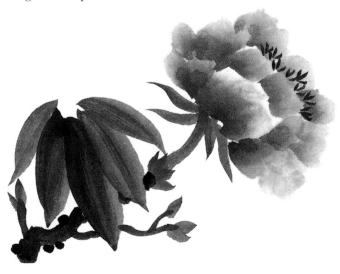

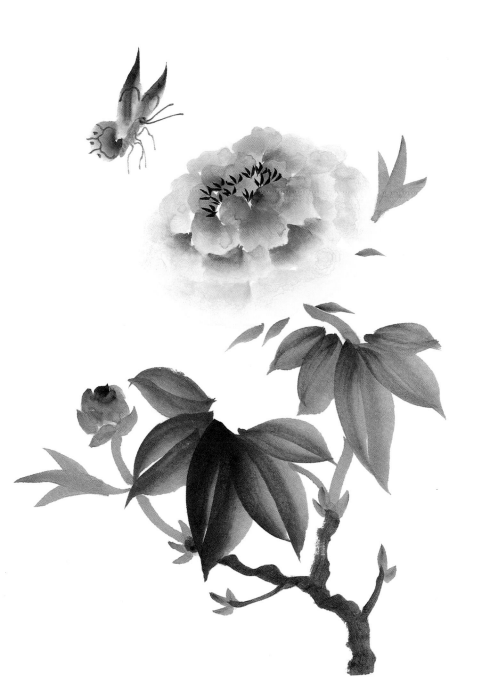

 # *MAKING CARDS*

Because of their simple design, the subjects in this book make ideal decorations for such things as cards, bookmarks, pottery and T-shirts.

To make cards and bookmarks, buy cardboard, in white or a soft pastel colour, thin enough to fold without making extra wrinkles. Cut the board a little smaller than twice the size of the envelope, to either a portrait (Fig. 1) or landscape (Fig. 2) format.

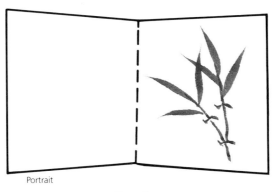

Portrait

FIG. 1

Landscape

FIG. 2

If you have difficulty in folding the card, use a ruler and the back of the cutting knife to score a line down the middle — on one side is usually enough.

Paint the picture on a piece of rice paper slightly smaller than the front of the card (to allow a border), and then mount it on the coloured cardboard. If the cardboard is white, you might like to add a soft colour wash before painting on the rice paper.

To apply the wash, you can use any of the following brushes:
- a Chinese wash brush, consisting of several goat's-hair brushes joined together by two dowels (Fig. 3)
- a *hake*, a broad Japanese brush made of rabbit hair (Fig. 4)
- a standard housepainting brush, 38 mm or 50 mm (1½ in or 2 in) wide (Fig. 5).

Check that the hairs are soft enough not to tear the rice paper. (These brushes are also useful for applying glue for mounting.) Add a little colour, such as burnt sienna, alizarin crimson or indigo, to a saucer half full of water, making sure all the colour is diluted, to avoid streaking. It is better for the wash to be too light than too dark, as you can always apply a second coat after the first is dry. Make sure there is enough wash — rice paper soaks up a lot of water.

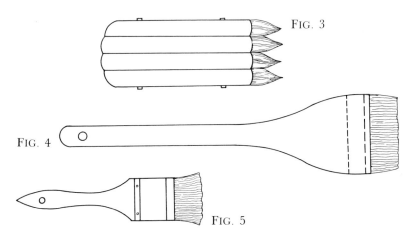

FIG. 3

FIG. 4

FIG. 5

Saturate the brush in the wash and apply in single strokes, overlapping them slightly and painting from side to side. Painting diagonally helps to give an even finish. Wait until the paper is dry before painting the picture. With a coloured background, white can be used for flower petals or butterfly wings. (Sometimes two coats of white are needed.)

FIG. 6

FIG. 7

FIG. 8

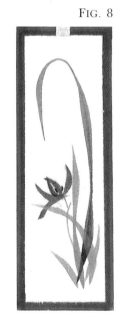

FIG. 6 For this card, the rice paper was torn with a watered line into a circle and mounted on coloured card.

FIG. 7 This design was painted on a wash background and mounted on white card.

FIG. 8 A bookmark edged with a Texta pen.

The painting must be completely dry before it is mounted. (Allow a week or so.) The colour should not run if you are using an ink-stick, as the glue will enter the water when you wash the ink off the brush and fix the other colours. Add a small amount of PVA glue to the water if there is any difficulty.

MOUNTING

Most paper pastes can be used for mounting. (Traditionally, a mixture of rice flour and water are used.) Add enough water to the paste to make a consistency that spreads easily, using a brush like the one used for the colour wash.

Lay the painting face down on a clean, non-porous surface — a laminated top is ideal. Apply paste to the back of the painting from the centre, working out in single strokes, as shown below. Don't go

over a stroke, or brush towards the centre, as this can cause creases, and too much working will break the paper up.

When the back is completely covered in paste, pick up the painting by two corners on a long side and lay it on top of the card. Make sure that you place it square-on, as it is difficult to adjust afterwards.

Lay one longer edge down first, slowly laying the rest of the picture down (Fig. 10, overleaf). Pat out any air bubbles with paper towel. (Paper towel is also useful to dab on any colour that has run, and will usually lift up any colour that is still wet.) A slight crease can

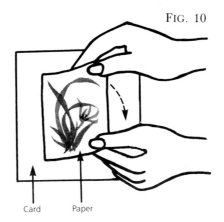

FIG. 10

Card Paper

be smoothed out with the back of your thumbnail when the picture is dry. A longer crease is best removed by gently pulling up the paper to the crease, lifting it clear of the cardboard and laying it down again carefully. If the cardboard buckles while drying, wait until it is dry and then lay it flat under some heavy books.

For mounting large pictures, a thick cardboard (10 sheet pasteboard) is best. After gluing the painting, leave it on the worktop and lay a piece of cardboard (cut about 2 cm or 1 in larger all round) directly on the painting and press down lightly. Don't rub, as this could smear the paint. Pick up the mounted picture from one corner in a single motion; the rice paper should have adhered to the board. Leave the extra margin to allow for framing or to square up later. Make sure the worktop is clean and dry before mounting the next picture.

Traditionally, the painting is mounted on a thicker, wider piece of rice paper, and silk strips are glued along the four sides to create a hanging scroll. This is fine when the painting is rolled up in a sealed tube, only being brought out to be shown over a cup of tea or displayed on various occasions, such as enhancing a season of the year. But for a picture that is to be displayed permanently, a frame with glass is the best protection. Mounting the paper first on board makes it more manageable. Pictures can also be framed unmounted, but they will show the wrinkles that form as the paint dries.

Traditional mounting is a specialised craft, but the above instructions should be enough for your own use.

SOME MASTER PAINTINGS

The paintings reproduced here illustrate "venerated traditions" of copying established forms to express the infinite wonder of life. While they all exemplify the Six Principles, in each case the reader's attention is drawn to one particular principle.

Orchids with Bee
Ch'i Pai-shih (1863–1957)

Accurate likeness The casual but sure lines of the well-proportioned vase, the brisk, flowing lines of the orchids and the finely detailed lines of the bee all express in a different manner the quality of each subject. Note the simple harmony thus produced.

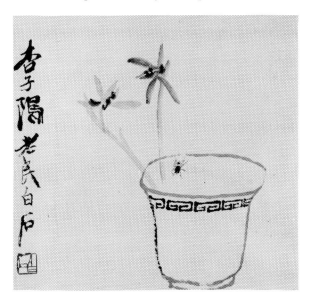

The Scent of Ripe Apples Attracts Birds
Anonymous
Colours on silk
Beijing Museum

Deft brushwork The bird's head and body are echoed in the shape of
the fruit. The leaves seem about to take flight.

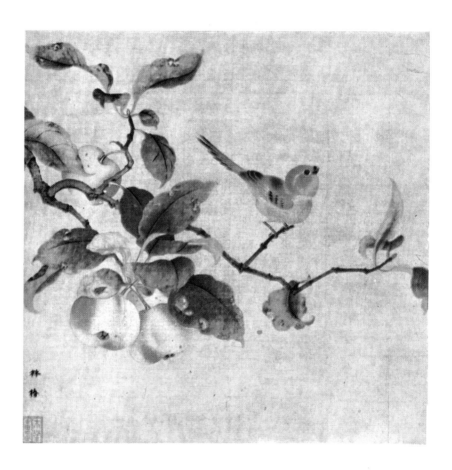

Cherry Twig
Hu Chêng-yen (1582-1672)
Engraving from the "Ten Bamboo Studio"

Well-planned space The red seal, repeating the shape and tone of the fruit, is placed to give the composition a circular movement. (If you cover the seal with your thumb, you will see that the composition becomes linear, following the bright colours, making the picture static.)

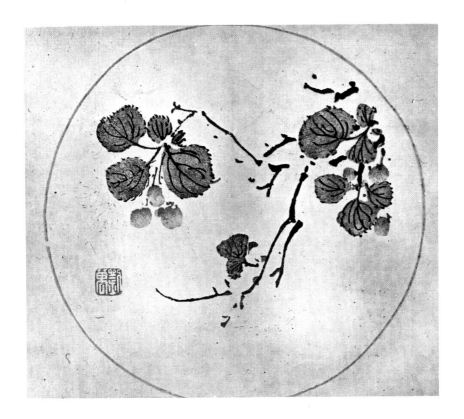

Bamboo
Wu Chên (attributed)
Ink on silk
Album leaf: 22.8 × 22.5 cm
Reproduced by courtesy of the Trustees of the British Museum, London

Lifelike spirit The broad base of the rock, strengthened by the dark moss dots, holds the bamboo firm as it springs from the earth. Each stroke is charged with strength, portraying the character of the artist.

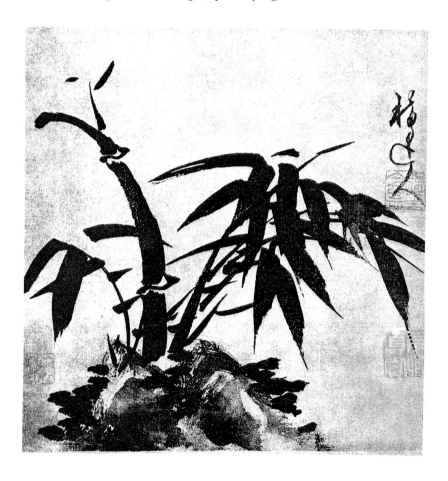

CALLIGRAPHY

The Chinese system of writing is based on visual images of the subject rather than being phonetic. For example, Fig. 1 denotes *sun* or *day*, being derived from the pictograph in Fig. 2. This is one of the 214 base words (called radicals). From these, compounds are formed. Thus, Fig. 3 (*sun* and *moon*) means *bright*, and there are many other complex extensions to represent all the required words.

FIG. 1 FIG. 2 FIG. 3

Each character can be expressed in a number of different scripts. There are six main scripts, but "Regular" script is usually learnt first and is best for our purpose. Once you have learnt to write a few characters (which is as much as can be attempted here), you might like to try adding one of the three good wishes on p. 115 to one of your paintings, placing it so as to maintain the balance of your composition. Chinese calligraphy is good practice in fundamental brush strokes and in the use of empty space.

Chinese calligraphy follows more formal rules than Chinese painting. Each stroke of a character must be made in a certain sequence to create the rhythm of that character. Consider the character for *eternity*. Writing it in the Regular (standing still) style, in the order shown, requires you to use the basic eight strokes of writing:

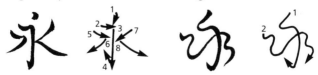

This will give you an understanding of the cursive (running) style.

Some other guidelines for writing characters are:

- Start from top to bottom:

three

- Do the horizontal stroke before the vertical:

Centre

- Paint the left side before the right side:

Good

- Do the middle stroke, then the side strokes:

Mountain

- When doing a box-like character, place the inside character before closing the bottom of the box:

Four

Here are three good wishes:

Long life

Happiness

Good fortune

PAINTING AND POETRY

As noted in the introduction, in the Chinese tradition it is difficult to separate painting and calligraphy. The same materials, principles and brush strokes are used in both, and both are expressions of the same artistic spirit. Just as a painting is silent poetry, so a poem brings forth a formless picture. Calligraphy, often a poem, is usually included in Chinese paintings, forming part of the composition.

As this book is intended for English-speaking readers, and as we are becoming increasingly aware of our own tradition of calligraphy, I have included a few examples of my own poetry which could be displayed beside a painting in fine handwriting. You may like to write your own poems to accompany your paintings.

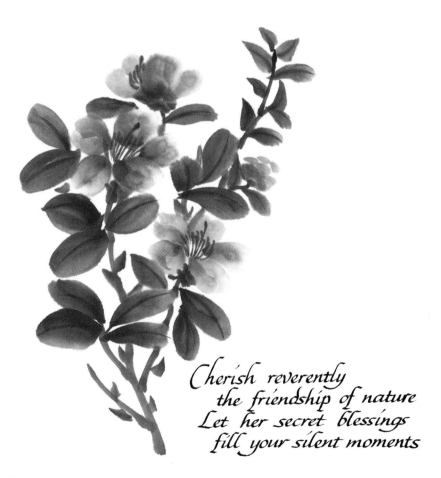

Cherish reverently
the friendship of nature
Let her secret blessings
fill your silent moments

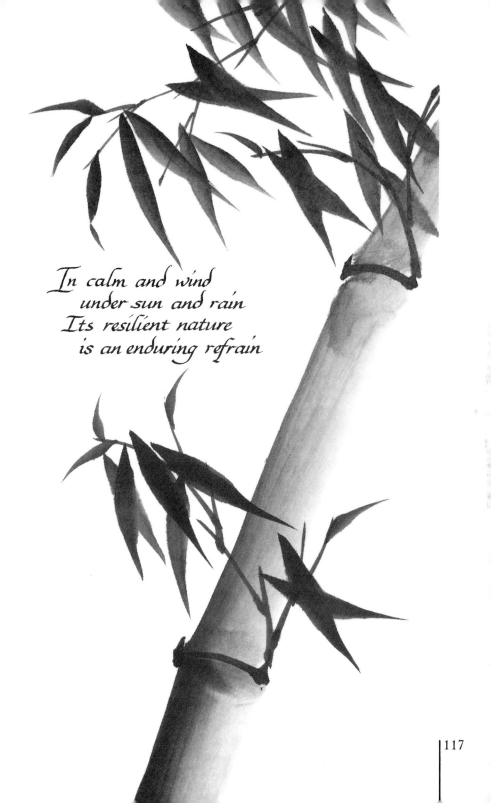

In calm and wind
under sun and rain
Its resilient nature
is an enduring refrain

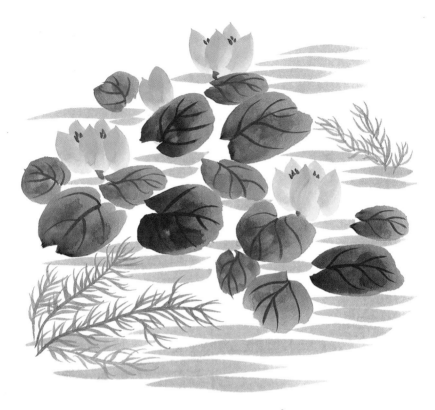

From river mud
 grow fragrant flowers
a thousand blossoms
 joyfully echo spring

SEALS (OR "CHOPS")

Seals come in many sizes and shapes.

The seal shown in Fig. 1 is relatively easy to carve with steel cutting tools, as the characters themselves are slowly scraped out.

Figure 2 shows the same words in vertical form, but more skill is required to scrape out the background, leaving the characters standing out in relief.

Both seals were carved in mirror image on soapstone from a saying my teacher gave me: "Peace be with you."

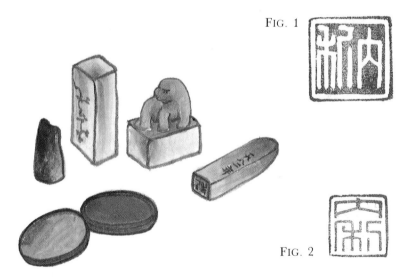

FIG. 1

FIG. 2

The position of the artist's square red seal completes the balance of a painting. Study as many oriental pictures as possible to gain an understanding of this relationship. Seals are also added as a sign of appreciation or of ownership, but always with an awareness of the need for visual harmony. They are traditionally carved out of a variety of materials, including soapstone, ivory, jade and wood, and nowadays are also made from rubber and plastic.

Sometimes a seal is the artist's family name, or it may be a painting name, assumed or given by another. It might be a phrase of a classical saying or even an animal symbol of the artist's birth year. Most seals have some means of designating which way faces forward. This is often a carved animal on top or a picture or calligraphy on one side.

The ink pad is a vermilion colour and oil based, so the ink takes a while to dry. An ordinary stamp pad is not suitable, as it is the wrong tone of red and is water based, which means it will blur when the picture is mounted.

Carving seals is a separate art requiring years of practice and knowledge of the special scripts used from ancient times. Both seals and ink can often be bought where other Chinese art materials are sold.